THIS BOOK BELONGS TO

· THE BLACK APPLE'S PAPER DOLL PRIMER ·

THE BLACK APPLE'S
PAPER DOLL PRIMER

ACTIVITIES & AMUSEMENTS
FOR THE CURIOUS PAPER ARTIST

EMILY WINFIELD MARTIN

POTTER
CRAFT

NEW YORK

Published in the United States by Potter Craft,
an imprint of the Crown Publishing Group, a
division of Random House, Inc., New York.
www.crownpublishing.com
www.pottercraft.com

POTTER CRAFT and colophon is a registered
trademark of Random House, Inc.

Library of Congress Cataloging-in-Publication
Data

Martin, Emily Winfield.
 The Black Apple's paper doll primer :
activities and amusements for the curious
paper artist / Emily Winfield Martin. -- 1st ed.
 p. cm.
 Includes index.
 ISBN 978-0-307-58656-8
 1. Paper dolls. 2. Handicraft. I. Title.
 TT175.M374 2010
 769.5'3--dc22

2010016328

Printed in China

Design by La Tricia Watford

10 9 8 7 6 5 4 3 2

First Edition

CONTENTS

ACKNOWLEDGMENTS

THANK YOU KINDLY:

To Josiah, my darling, brilliant partner in crime, the salt in my stew and the lace in my shoe. Without you, dirty teacups would tower mightily, I would be a bear that remained in hibernation year-round, and life would be incomprehensibly less cozy and fantastic.

To the disarming and fantastically clever Thom O'Hearn, coinventor of this paper doll world and owner and proprietor of the illustrious "O'Hearn Idea Factory" (where every day is a banner day), Rebecca Behan, Chi Ling Moy, La Tricia Watford, and to the rest of the wonderful folks at Potter Craft for taking this book out of the realm of the imaginary.

To Amy, who constantly dazzles and comforts, and to her family, who let me belong. To friends from near and far who give support and inspiration and indulge me in endless nerdiness.

Finally, to Mom, Amelia, Stephen, Kristian, and the rest of my family—who even the most hilarious, warmhearted, thoughtful writer could never hope to make up. I count myself lucky to call you my own.

INTRODUCTION

When the opportunity arose to create a Black Apple paper doll book, I knew it was a stars-are-aligning, perfect project. So perfect, in fact, that I was unclear about why I hadn't dreamed one up before. You see, the pseudonym I use, "The Black Apple," encompasses everything I make, every character I create, every world I dream up. These have taken the form of paintings, drawings, books, dolls, and more, so why not a whole book populated by Black Apple paper dolls (and paper doll–related things)? Soon visions of tiny dresses and fancy lettering and pint-sized backdrops danced in my head as I drifted off to sleep . . . but a whole book of paper dolls? It was such a curious idea, but I am by trade a maker of curious stuff, and with a prodigious amount of plotting and planning and scheming and sketching (and the help of some excellent book elves), the idea unfurled itself into a whole, fully formed book as if it had always been so.

Paper dolls are unique, alchemical sorts of things; even though they have relatively humble beginnings (and only two dimensions), they can come to life in all sorts of ways. As a medium, they have assumed every identity imaginable over the years—Victorian ladies, mermaids, soldiers, mod '60s girls, cartoon mice, and now my little characters and creatures, too. During the Great Depression, paper dolls reached what was arguably their pinnacle of popularity in the United States. Paper toys could be afforded by all. These blank, people-shaped canvases represent the ultimate back-to-basics toy, and with all the modern gadgets and expensive thingamajigs we're inundated with today, there's something to be said for that. The simple beauty of paper dolls can be a comfort in times of upheaval and uncertainty. There is nothing quite like the act of cutting them out and dressing them up, and I dare you not to feel at least a little nostalgic and cozy when you do it.

In your jaunt through the book, you'll discover all sorts of things to do beyond the classic game of dress-up (but please don't forget to play dress-up!). You'll encounter a motley cast of original Black Apple characters, an entire library of painted scenes, a section dedicated to creating dolls of your very own, and a collection of clever things to make and do with your paper pals and the other things contained herein. You can read and create little stories, meet Abraham Lincoln, create paper versions of yourself and your family, build a paper theater, and direct a stop-motion film. A paper world is bundled up in the pages and ink and binding here, just waiting to be explored.

I hope you love it.

HOW TO USE THIS BOOK

More than once I have spied a really lovely uncut sheet of vintage paper dolls and thought of how perfectly at home it would be in a frame. Of course, I also know that those dolls were meant to be played with . . . and I think that the impulses to frame them and to cut them up and move them around and give them funny voices are equally sensible. So if you wish to keep this book just for looking at, that is perfectly fine. If you wish to use it as a functional, cut-up-able toy, well, we made sure to print the dolls themselves on nice, sturdy paper so you can do just that. Finally, if you want to (paradoxically) do both, that is possible, too! The following pages will help you figure out how to use this book, however you'd like to go about it.

To Cut or Not To Cut

First, let's talk about the whole cutting-up-the-pages aspect of this book. I believe that beautiful things are made to be used. I drink from my prettiest teacups every day, I write on (rather than hoard) my prettiest stationery, and I attempt to fearlessly cut into precious yardage of completely irreplaceable vintage fabrics. But in the spirit of total and complete honesty, I have to tell you that it wasn't always this way.

As a child, I often received some lovely little packet, such as the *Wizard of Oz Paper Dolls* set. I would open it up, gaze at Glinda's beautiful pink dress, Dorothy's pinafore, and the munchkin mayor's suit . . . all with hopeful little tabs out, waiting to be trimmed.

I would pick my favorite.

I would pick up the scissors.

And then panic would set in—for something cut can never be uncut. Therein lies the paper doll conflict.

I think it's probably a normal, fussy little-girl issue, because of course I wanted to play with the dolls and the clothes, but I also wanted to keep my pretty book perfect and complete. The solution to this paper crisis is one that clever mothers (well, at least those who were parenting after the invention of the color photocopy machine) devised: Make color copies of the dolls and clothes. This way, you don't have to choose between playing with the dolls and keeping the beautiful book whole. This would've been such a comfort to my eight-year-old self, as I, utterly exhausted with option-weighing, would sometimes just decide to keep the book whole and perfect rather than be a scissor-wielding rebel. Whatever *your* propensity, dear book owner—whether you want to slice into this volume with abandon (because it is, after all, your book) or make copies of your favorite playthings and keep the book pages intact—enjoy.

Tools for Doll Making

The lion's share of the tools you'll need to use this book are familiar and simple, and you'll likely already have most of them. These tools should be used only by (or in the company of) a grown-up person, so please remember to ask for help if you aren't a person of the grown-up variety.

CUTTING TOOLS

Most of the time, you'll simply be trimming around the solid drawn outline of the doll or other item you wish to cut out. Occasionally, I've drawn dashed lines, like this (- - - - - -) in a small area in the interior of a doll or a piece of clothing. These small details should be cut out as well, and can be done so most effectively with a craft knife.

Hint: It probably goes without saying, but be sure to do all your cutting work with plenty of good light and on a solid worktable or counter.

Scissors: For general cutting purposes, you can't beat a pair of good-quality, medium-sized sharp scissors. For most of the dolls, clothes, and ephemera in this book, this is the only tool you will need.

Craft knife: For cutting small details and making interior cuts, a craft knife (such as an X-Acto) works best. Be sure to use a self-healing cutting mat (easily found at most sewing, craft, and office stores) as a safe, protective barrier between the knife and your work surface. A large wooden cutting board would work here, too.

Hint: Please be careful when using a craft knife—the blade is ultrasharp! Work on a stable surface that is unlikely to slip, and keep your fingers as far as possible from the blade tip while you work.

ADDITIONAL SUPPLIES

Some general supplies will come in handy for the later sections of the book.

Adhesives: All-purpose glue (such as Elmer's all-purpose), wood glue, rubber cement, and spray adhesive. When applying glue to a paper doll, rubber cement often is my adhesive of choice for one important reason: It's not permanent. You can carefully separate paper parts glued with rubber cement if you decide to change them later. If rubber cement is listed in the Materials list for a project, I chose it specifically to allow for later adjustments or replacements.

Art supplies: Pens, pencils, markers, liquid ink, and acrylic paint. These supplies are discussed in detail in Part Two, under Materials for Customizing (page 91).

Various paper goods: Decorative papers and envelopes and paperstock of assorted weight.

Photocopying

If you'd like to cut and play with the dolls in this book while leaving the book intact, here are a few tips for photocopying:

✳ Photocopy the dolls onto heavyweight paper. Using a sturdy paper, such as card stock, will allow the dolls to stand without wilting or flopping over.

✳ Photocopy clothing onto lightweight paper. Standard copy paper is perfect and will allow you to fold the tabs easily.

✳ Photocopy scenes or any other items in the book as recommended in the project notes or, if not specified, onto the type of paper you like.

DOLLS AND CLOTHES

A CURIOUS WORLD OF DOLLS AND STORIES

When I am making a painting, drawing, or even a doll, I usually think of it as an illustration for a story—even if that story doesn't exist outside my mind. Paper dolls make perfect illustrations for these stories, and they're extra wonderful because they are illustrations that can be removed from the flat page and taken into your own living, breathing, three-dimensional world. How wonderful it would be if, when we opened up a copy of *Alice's Adventures in Wonderland*, we found illustrator John Tenniel's beautiful characters at the ready for us to take up and out of the book. You could perch the Cheshire Cat on *Alice's* shoulder. You could tuck Mock Turtle into your pocket. The paper dolls and clothing and doodads and thingamajigs you'll find in this part of the book are like that— except that I've recorded only a little scrap of the story for you. The rest of their little lives are for you to make up! These are portraits of imaginary characters—a band of misfits, if you will—and I've made them with the hope that they'll be equally at home being flipped through and peered at, or cut out and played with.

Each character comes complete with an original wardrobe that corresponds to his or her particular quirks and tastes, so be sure to make good use of those. You can even transform your dolls into puppets and act out the stories using The Black Apple Theater (featuring two entirely different and interchangeable prosceniums) and the scene library (which contains backdrops against which your thrilling tales can come to life).

⚓ CORA ⚓

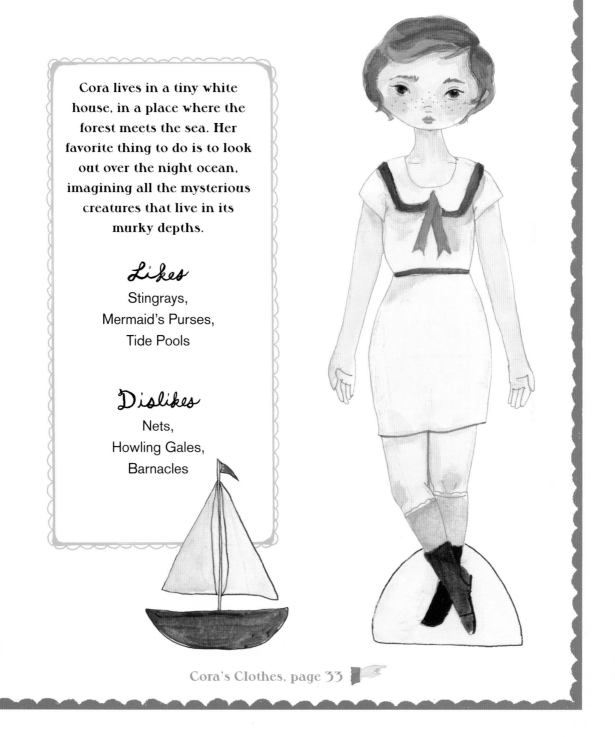

Cora lives in a tiny white house, in a place where the forest meets the sea. Her favorite thing to do is to look out over the night ocean, imagining all the mysterious creatures that live in its murky depths.

Likes

Stingrays,
Mermaid's Purses,
Tide Pools

Dislikes

Nets,
Howling Gales,
Barnacles

Cora's Clothes, page 33

STELLA

Stella works in a hospital by day, but whenever she gets the chance she loves nothing more than dancing the night away. She has a bad habit of introducing herself using fake identities.

Likes

Dancing the Jitterbug,
Fancy Hats,
Sour Candies

Dislikes

Holes in Her Stockings,
Getting Splashed by
Rain Puddles,
Bores

Stella's Clothes, page 35

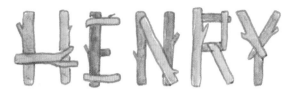

Henry is a woodsman who spends his days in the ways you might imagine a woodsman does. He keeps his small cabin very tidy and prefers honey to syrup.

Likes
His Pipe,
Mystery Stories,
Flapjacks

Dislikes
Idle Chatter,
Termites,
Poorly Researched
History Books

Henry's Clothes, page 37

Cat

By age eight, Cat preferred serious books like *Moby-Dick* to silly stories. So, her friends and family were surprised when, as an adult, she opened a children's bookstore . . . but now she happily spends her days caring for her pet finches, reading to little people, and dreaming of great whales and silliness alike.

Likes

Birds, Hot Toddies, Crunching Leaves

Dislikes

Torn Book Jackets, Spoiled Ice Cream, Board Games with Too Many Rules

Cat's Clothes, page 39

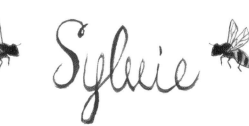

Sylvie

Sylvie is descended from three generations of French beekeepers but has a curious aversion to honey. She raises rabbits and likes to think that if they ever were to decide to speak to someone, they would speak to her.

Likes

Old Cartoons,
Natural History Museums,
Elbow Patches

Dislikes

Sticky Floors, Cold Hands,
Braggarts

Sylvie's Clothes, page 41

Eleanore

Eleanore lives in a little apartment with green walls, where she sews beautiful dresses all day long. Her cat, *Atticus*, is her best sewing assistant, and she likes to sing him silly songs, incorporating his many nicknames.

Likes

Very Hot Soup,
Moths (Small, Brown Ones),
Old Quilts

Dislikes

Itchy Sweaters,
Loud Televisions,
Sad Lobsters

Eleanore's Clothes, page 43

ROSE

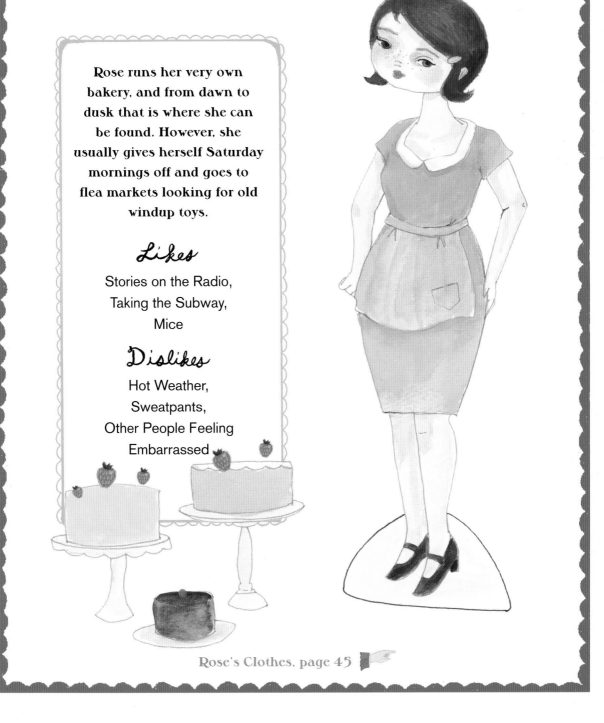

Rose runs her very own bakery, and from dawn to dusk that is where she can be found. However, she usually gives herself Saturday mornings off and goes to flea markets looking for old windup toys.

Likes

Stories on the Radio,
Taking the Subway,
Mice

Dislikes

Hot Weather,
Sweatpants,
Other People Feeling
Embarrassed

Rose's Clothes, page 45

TOM

Tom is a mystery, even to his own wife. He might vanish for days at a time and then suddenly appear at the very diner where you just so happen to be having a cup of coffee and a piece of pie. It is rumored that his past occupations include cobbler, rat-catcher, and ringmaster.

Likes
Trains,
Pocket Watches,
November

Dislikes
Falling Down Stairs,
Thieves,
Potato Eyes

Tom's Clothes, page 47

OLIVER, JANE + BABY

Oliver, his sister Jane, and
their small sibling Baby live
on an unremarkable street,
in an unremarkable town.
Consequently, they spend a
great deal of time imagining
that they live aboard a pirate
ship or in a forest populated
by elves and monsters.

Likes

Wooden Legs (Oliver),
Fairy Houses (Jane),
Candy Canes (Baby)

Dislikes

Hot Sauce (Oliver),
Lizards (Jane),
Being Poked (Baby)

Oliver, Jane, + Baby's Clothes, page 49 ☞

HAZEL + OLIVE

Hazel and Olive are twins—
very special, conjoined
twins—and the starring
act of Huxter's *Amazing
Traveling Carnival.* Their
dance routines are sometimes
jazzy, sometimes graceful, and
always dazzling.

Likes
Stories About Orphans (Hazel),
Dancing Bears (Olive),
Toast with Jam (Hazel)

Dislikes
Grumpiness (Olive),
Too-Tight Shoes (Hazel),
Stories About Orphans (Olive)

Hazel + Olive's Clothes, page 51

NATE

Nate is the foremost expert that he knows of on imaginary and mysterious animals. He spends every weekend at the movie theater watching whatever strikes his fancy (usually comedies, because there aren't nearly enough movies about sea monsters).

Likes
Magic Tricks,
Grilled Cheese Sandwiches,
Arcade Games

Dislikes
Tickling, Kickball,
Getting Gum Stuck in His Hair

Nate's Clothes, page 53 ☞

BORIS

Boris has spent his life traipsing the world with various vagabonds in a dazzling, musical traveling show.

Likes
Sleeping in Grass,
Chocolate Pie,
Gentle Children

Dislikes
Muzzles,
Being Dressed in
Lady-Bear Clothing,
Greedy Children

Boris' Clothes, page 55

Alice

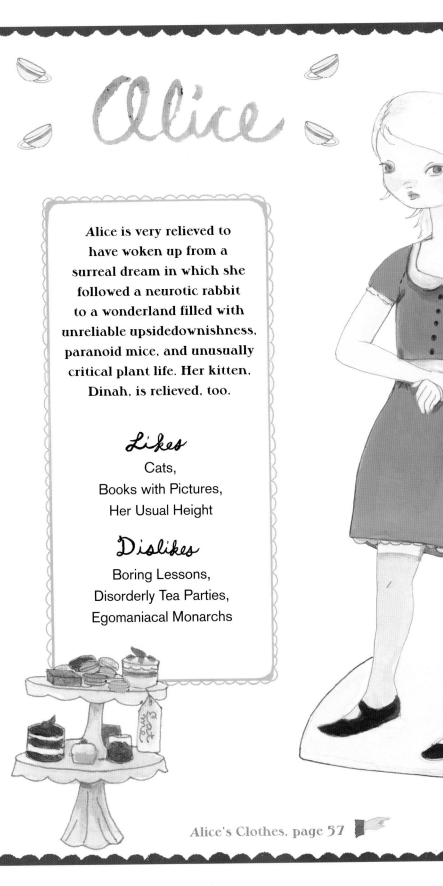

Alice is very relieved to have woken up from a surreal dream in which she followed a neurotic rabbit to a wonderland filled with unreliable upsidedownishness, paranoid mice, and unusually critical plant life. Her kitten, Dinah, is relieved, too.

Likes
Cats,
Books with Pictures,
Her Usual Height

Dislikes
Boring Lessons,
Disorderly Tea Parties,
Egomaniacal Monarchs

Alice's Clothes, page 57

JACK

Jack works in a small but respectable comic-book shop during the day and listens to his favorite albums on his beloved record player at night. He is creating an autobiographical comic book but worries that it will embarrass his family.

Likes

Graph Paper,
Documentaries,
Buttons

Dislikes

Untied Shoelaces,
Leaky Pens,
Gloomy Sundays

Jack's Clothes, page 59

· VIOLAINE ·

Violaine is happy only in the
cool darkness of her black-
and-white photography lab.
There, with nothing but her
photo chemicals and trays of
partially developed images for
company, she can listen to her
music and wonder why no one
reads poetry anymore.

Likes
Music from
Before She Was Born,
Black Swans,
Tea with Lots of Sugar

Dislikes
Stand-up Comedy,
Warm-Weather Vacations,
People Her Own Age

Violaine's Clothes, page 61

GHOSTIE
+
HEDGIE
+
ONIONHEAD

This odd little trio lives in a mysterious place called Milkland, where they have adventures (real and pretend) every day but always make it home safe in the evening for a cookie and a glass of milk.

Likes

Apples (Ghostie),
Shadow Puppets (Hedgie),
Red Balloons (Onionhead)

Dislikes

Scary Movies (Ghostie),
Flying Kites Alone (Hedgie),
Making People Cry (Onionhead)

Ghostie, Hedgie, + Onionhead's Clothes, page 63 ☞

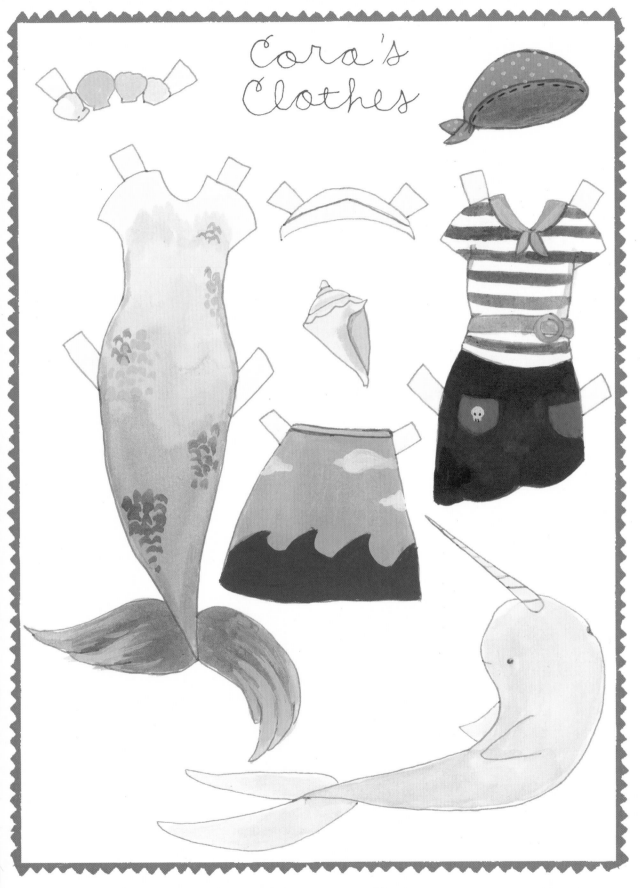

Cora's Clothes

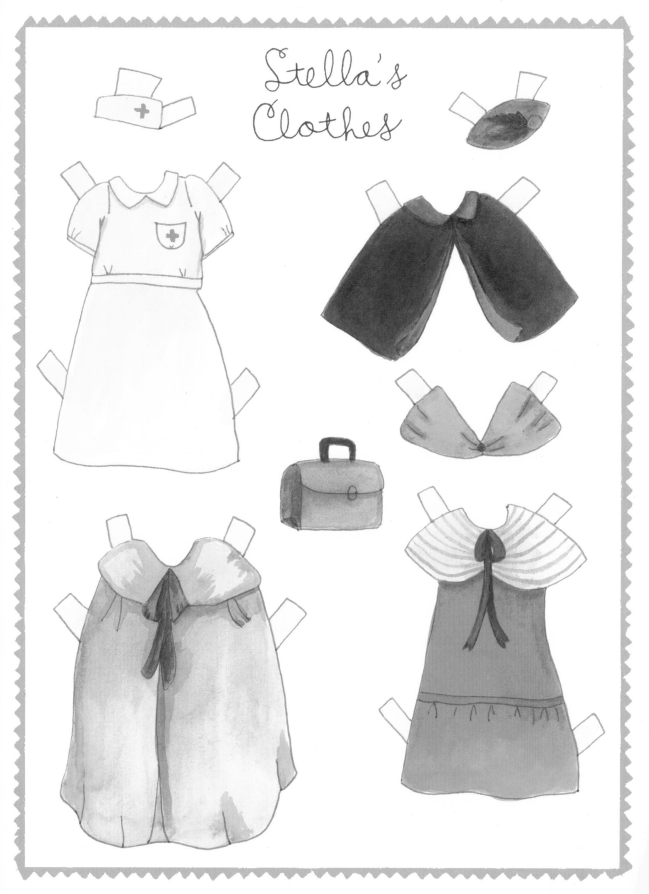

Stella's Clothes

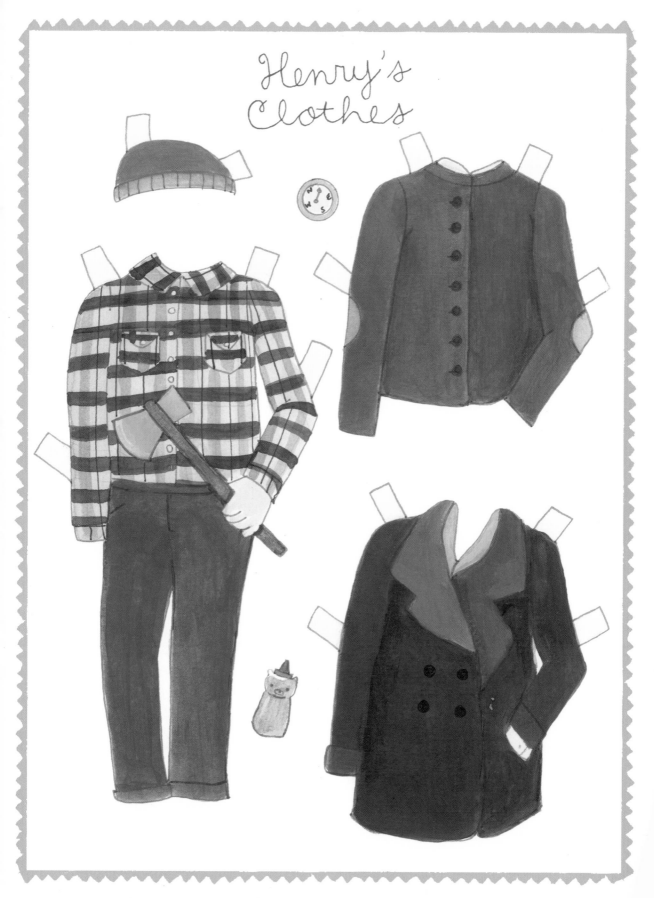

Henry's Clothes

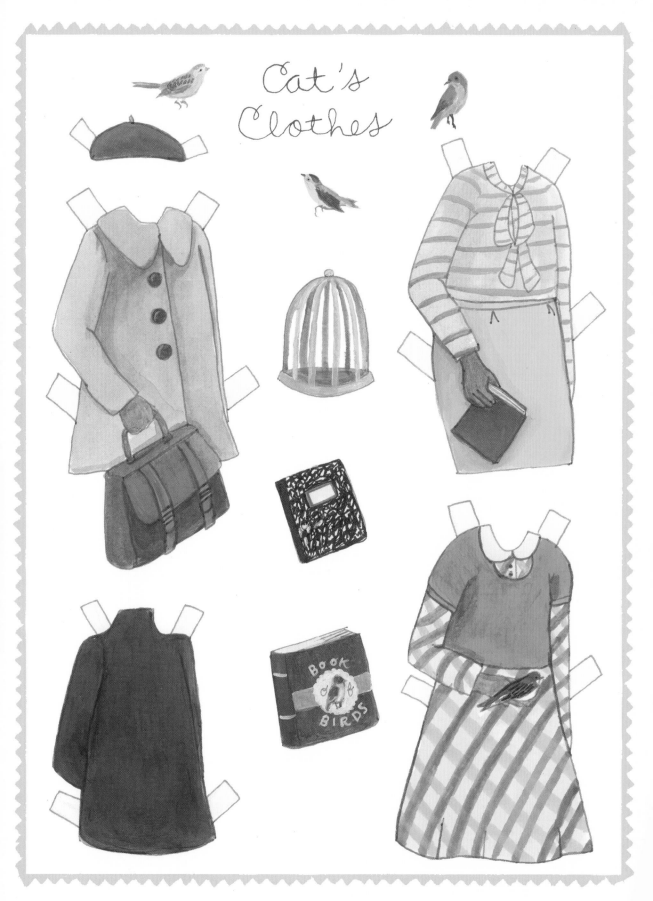

Cat's Clothes

BOOK of BIRDS

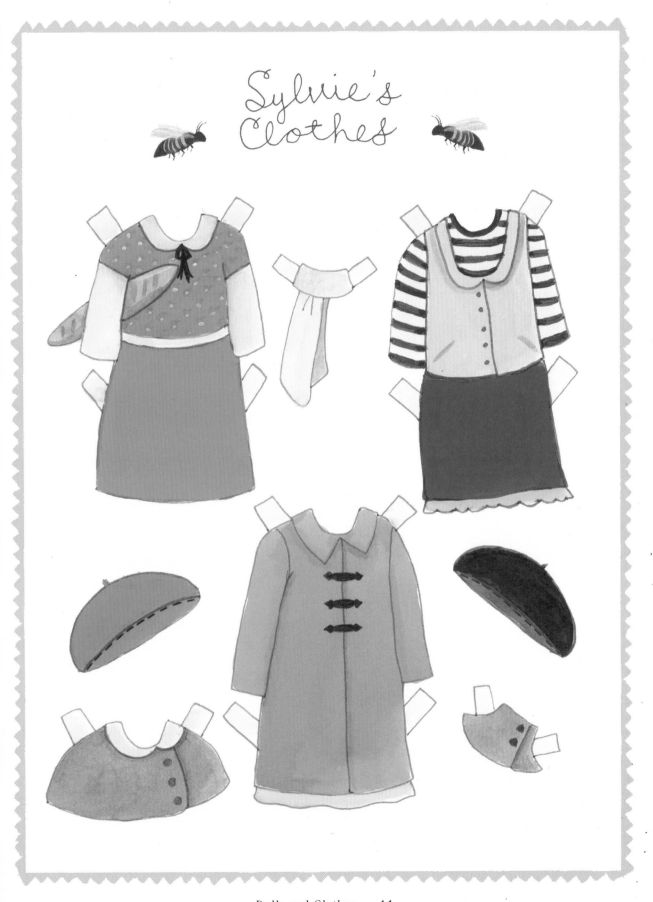

Sylvie's Clothes

Eleanore's Clothes

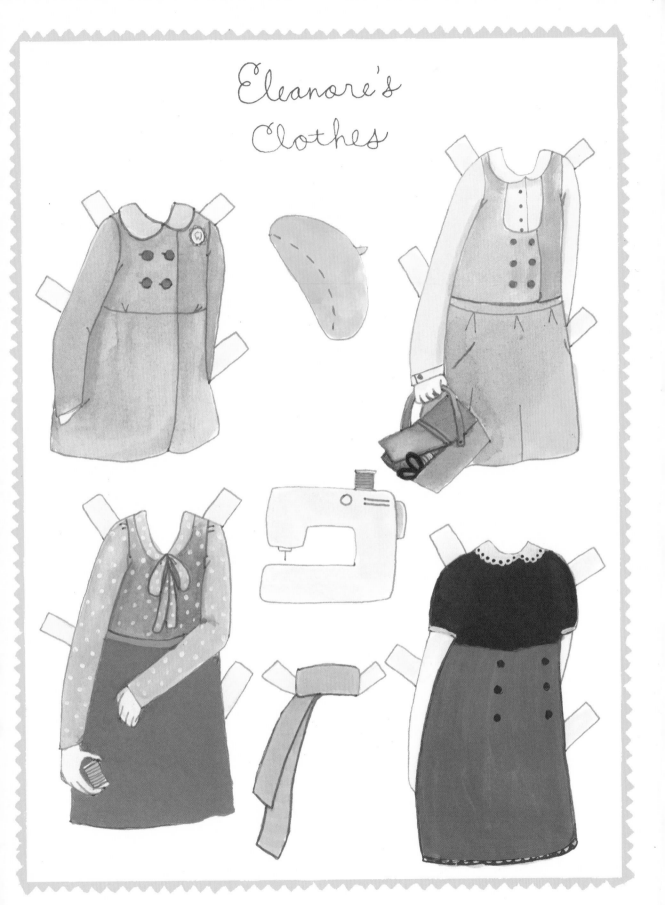

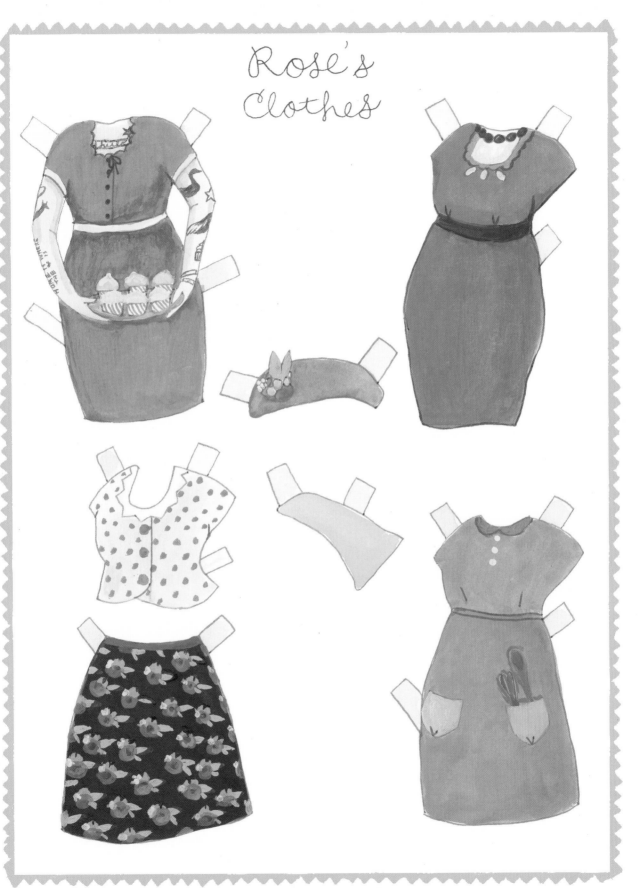

Rose's Clothes

Tom's Clothes

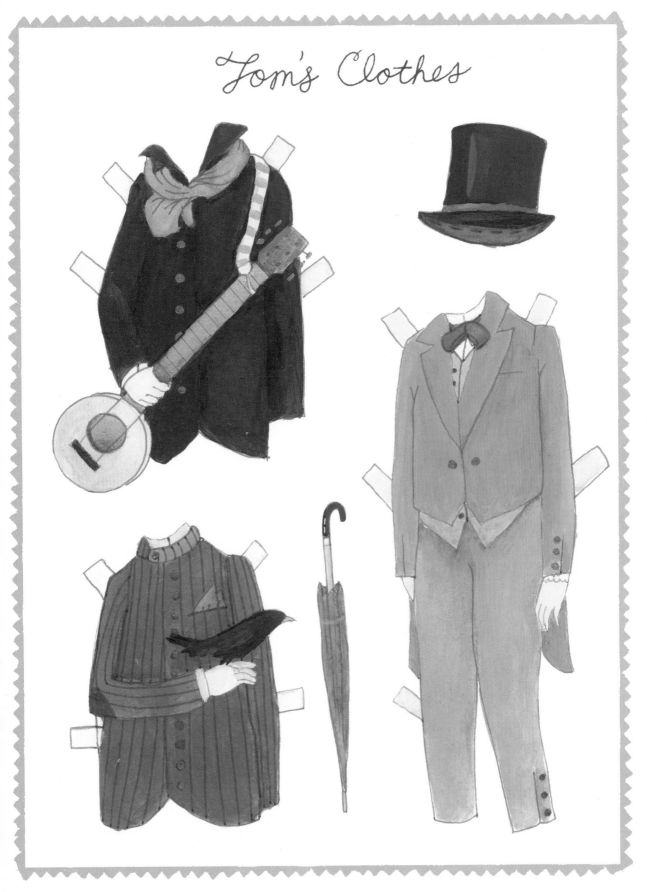

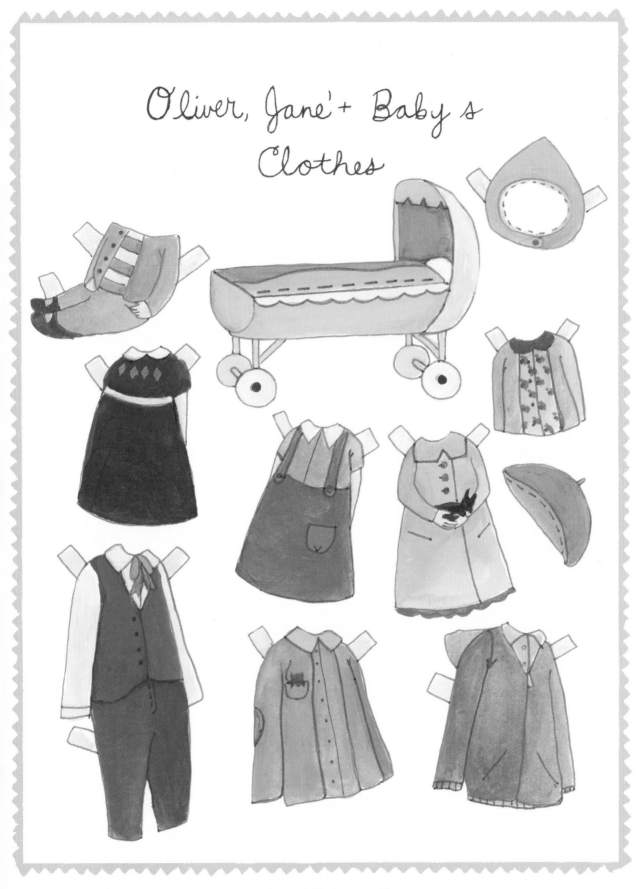

Oliver, Jane' + Baby's Clothes

Hazel + Olive's Clothes

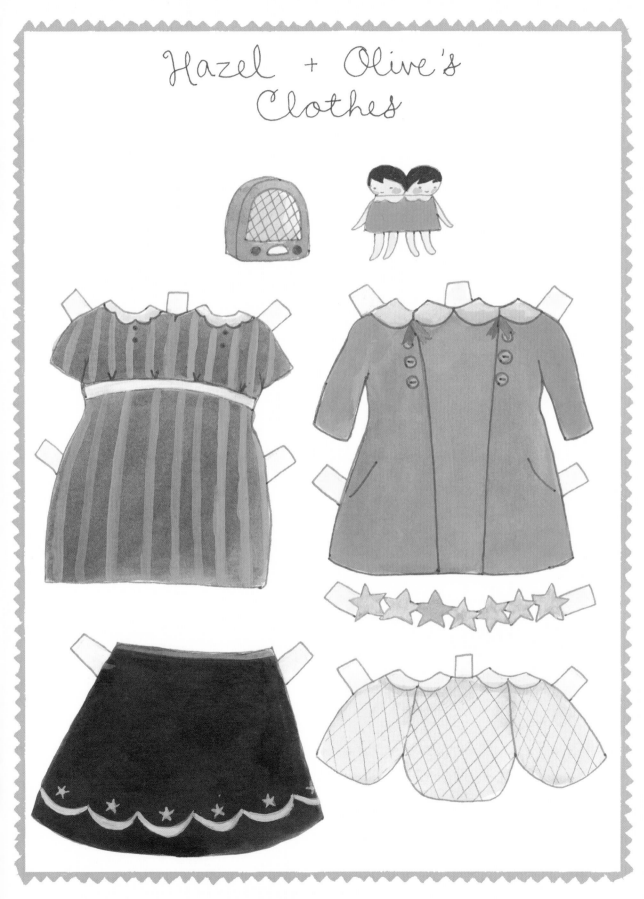

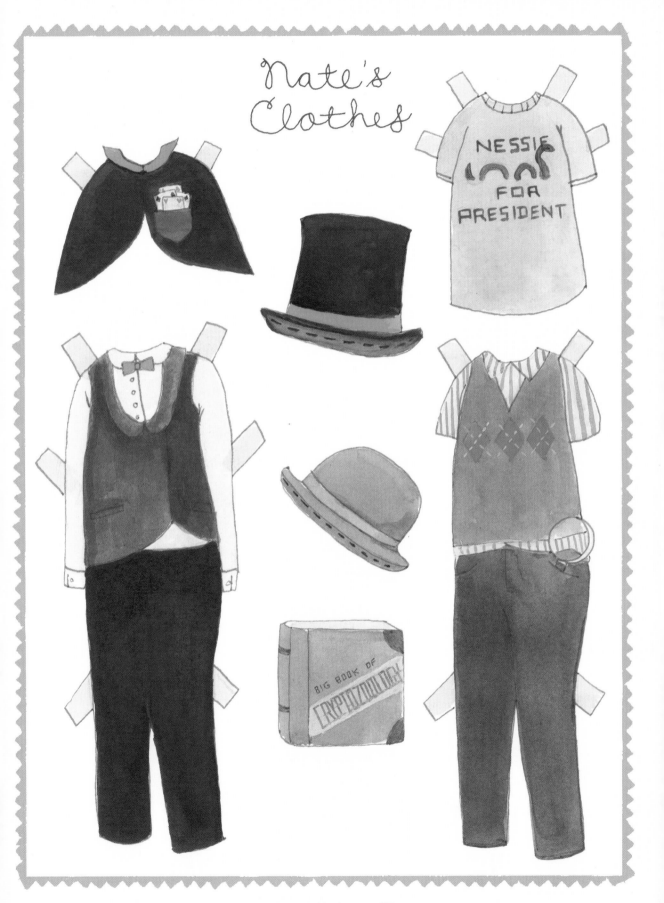

Boris' Clothes

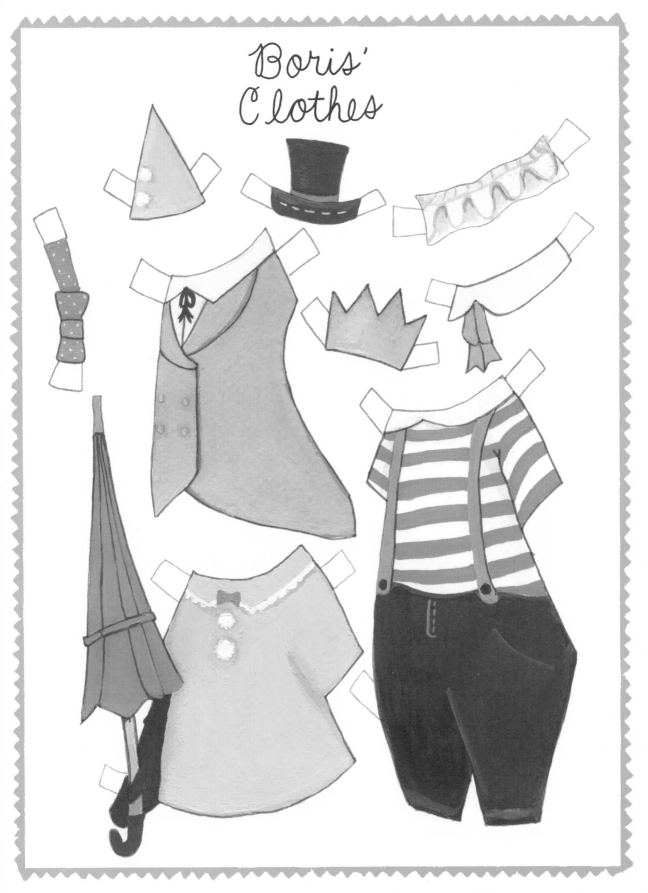

Alice's Clothes

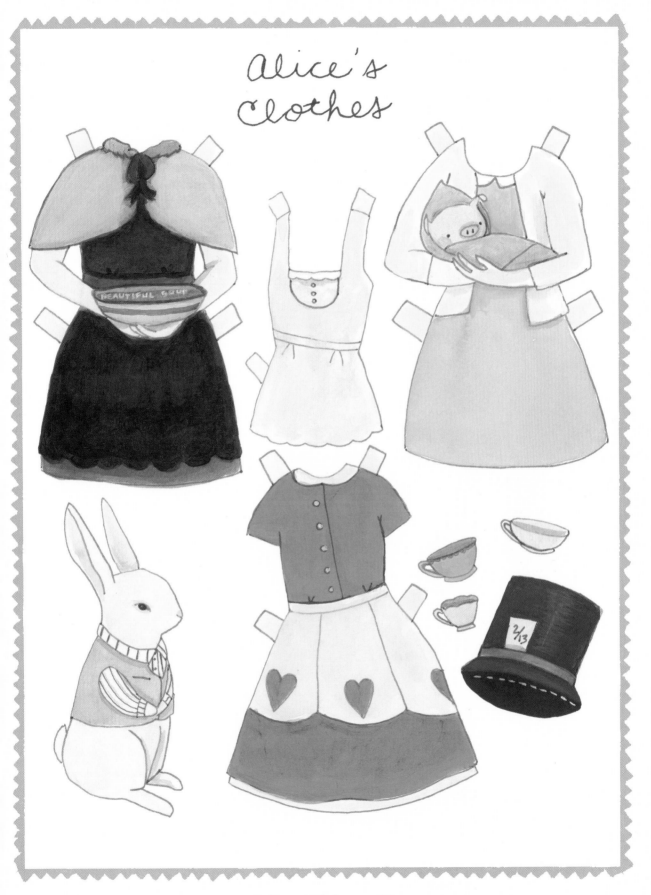

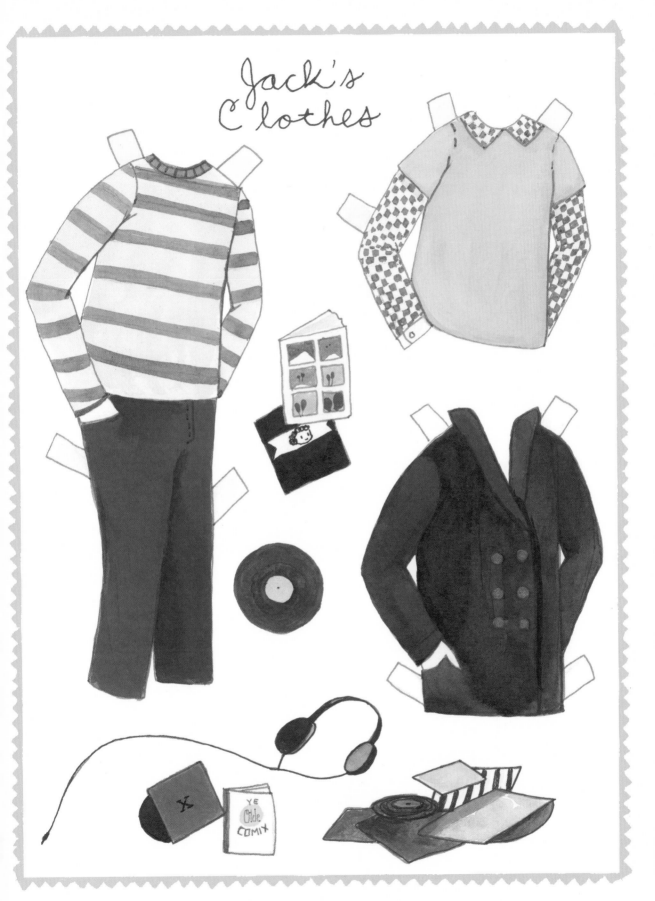

Jack's Clothes

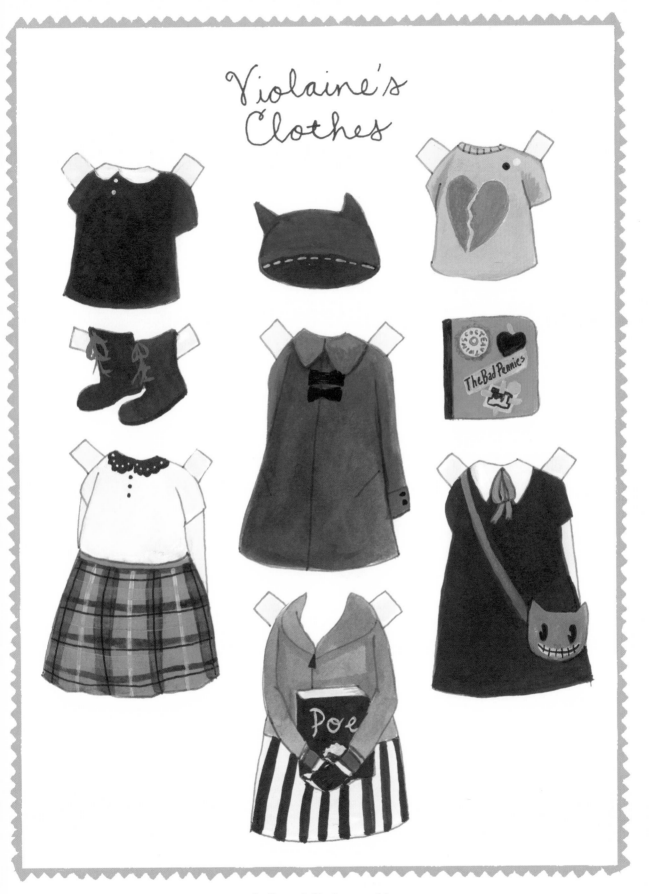

Violaine's Clothes

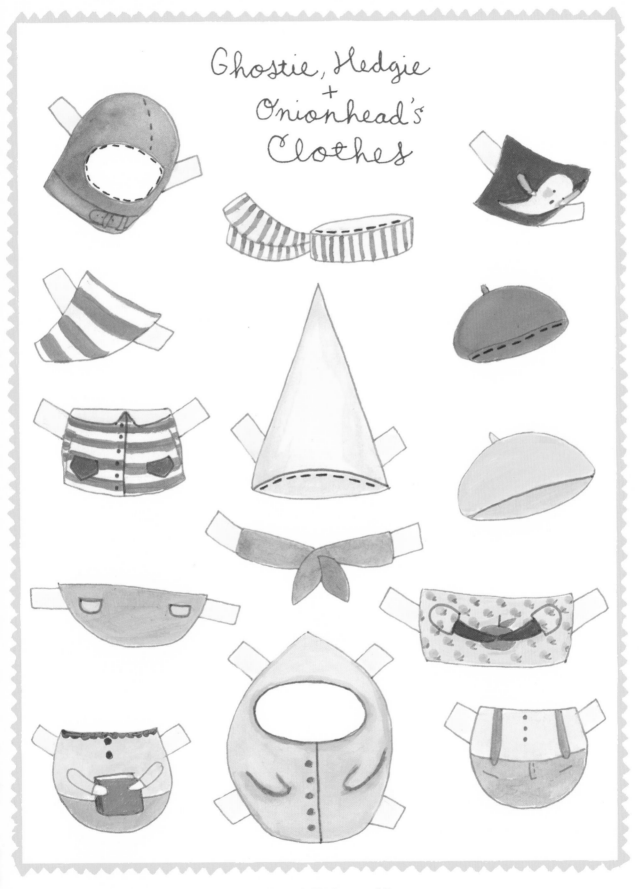

Ghostie, Hedgie
+
Onionhead's
Clothes

THE SCENE LIBRARY

This collection of scenes gives you a variety of backdrops to use with The Black Apple Paper Theater (page 78), or with later projects in the book (such as the Play Set on page 140 and the Flip Book on page 146). You can also use them by simply propping your book open (a book stand would come in handy).

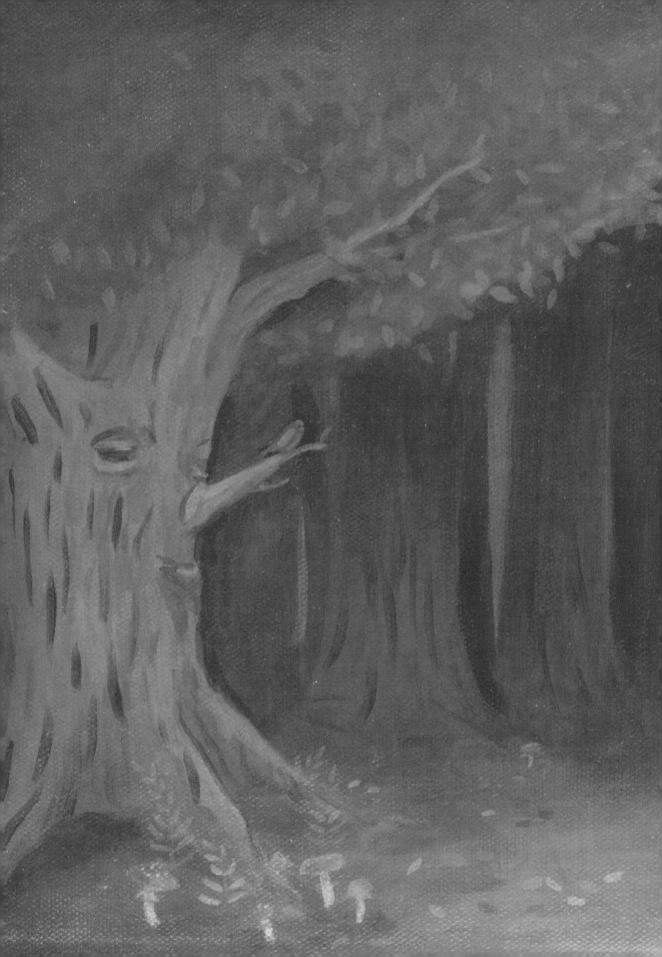

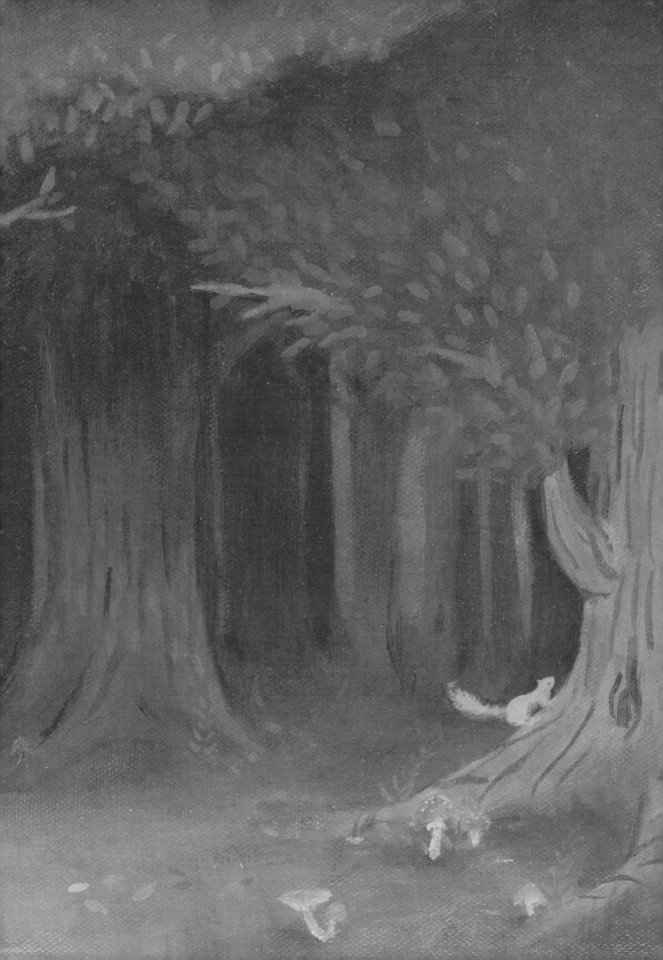

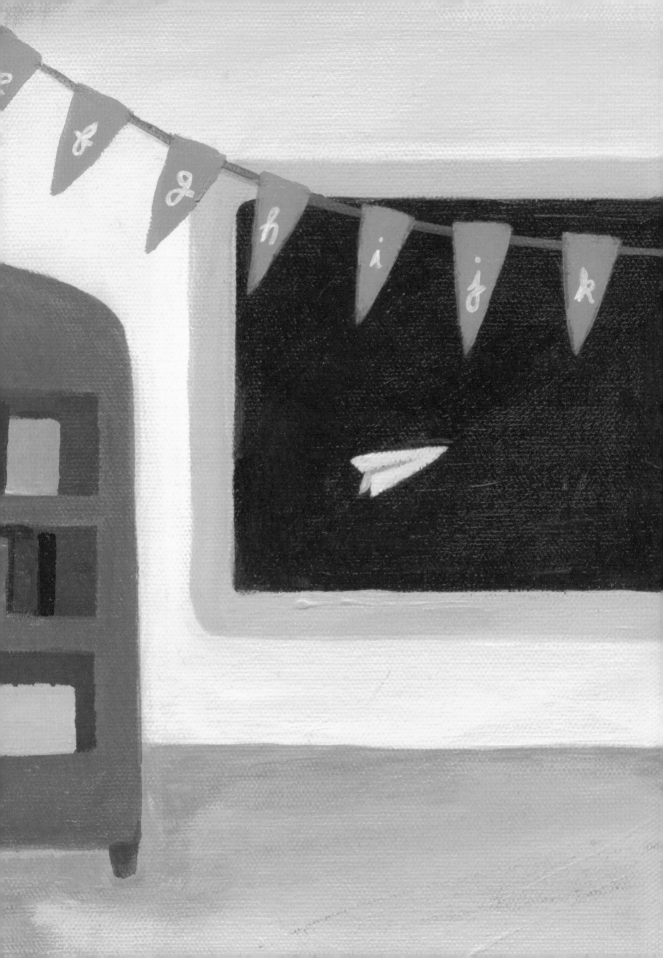

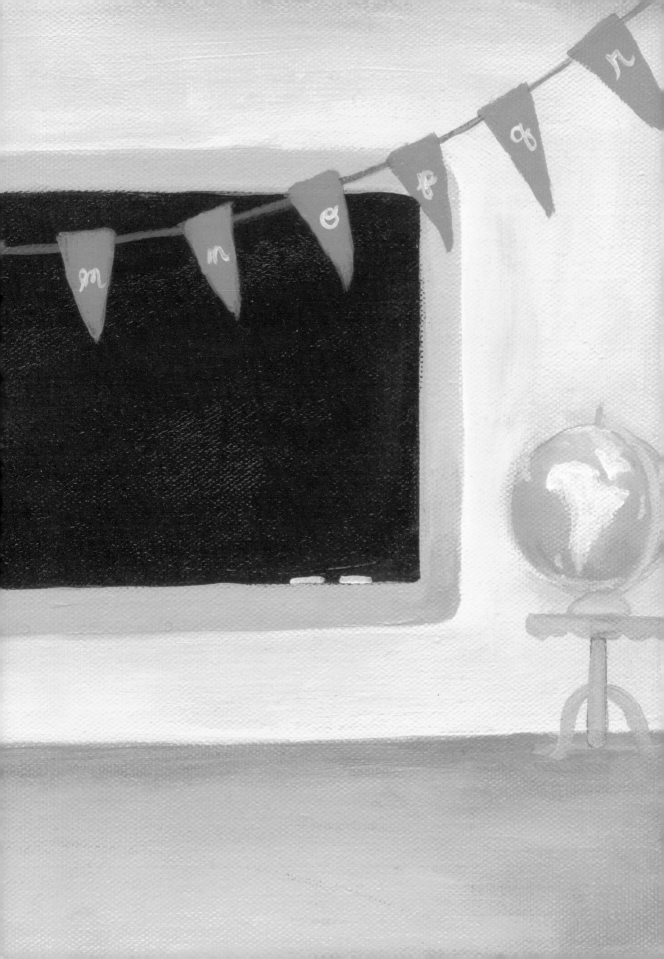

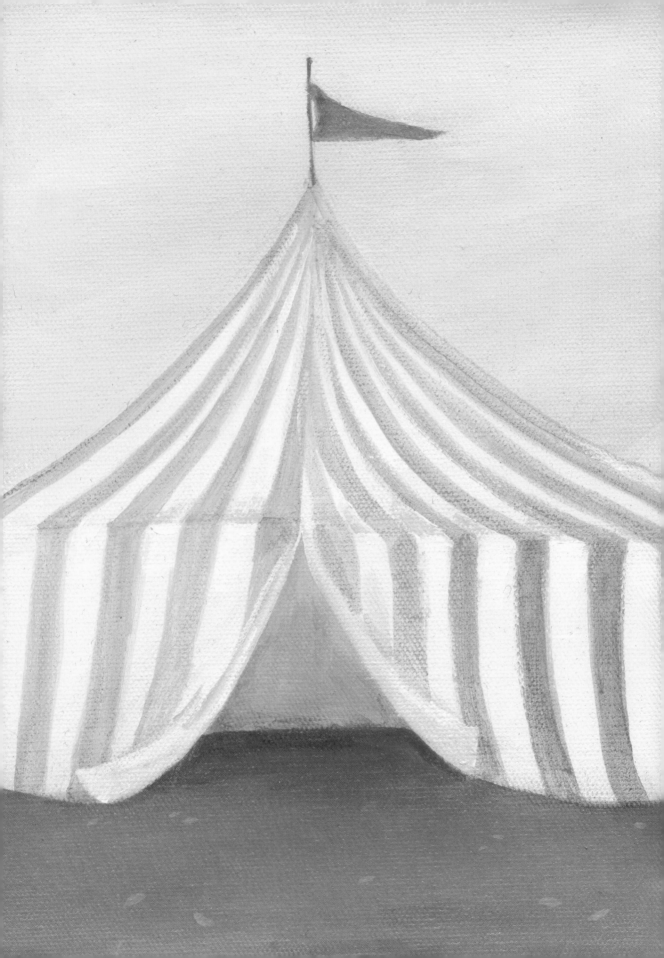

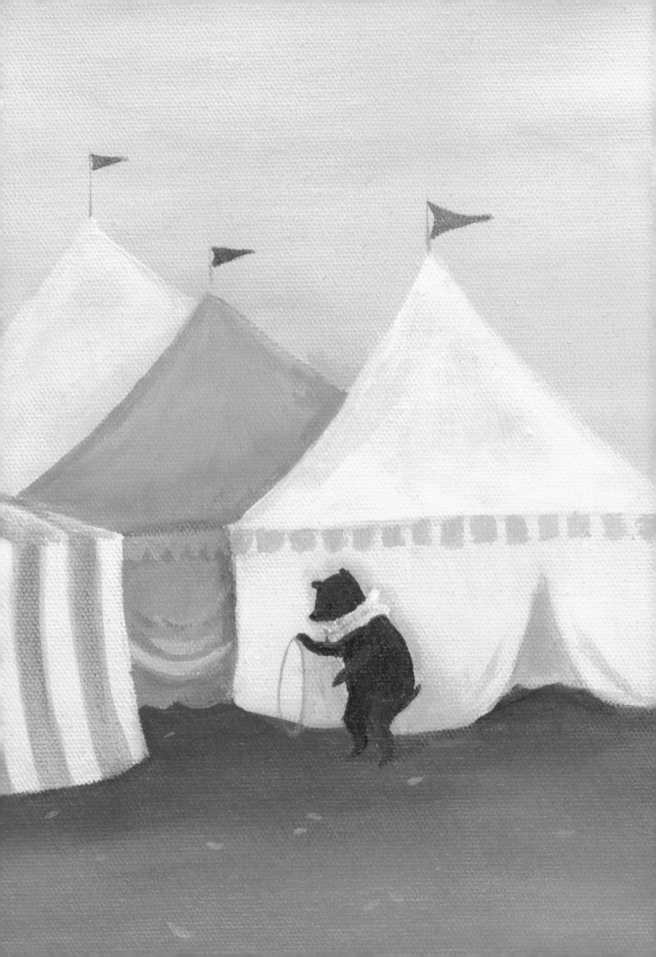

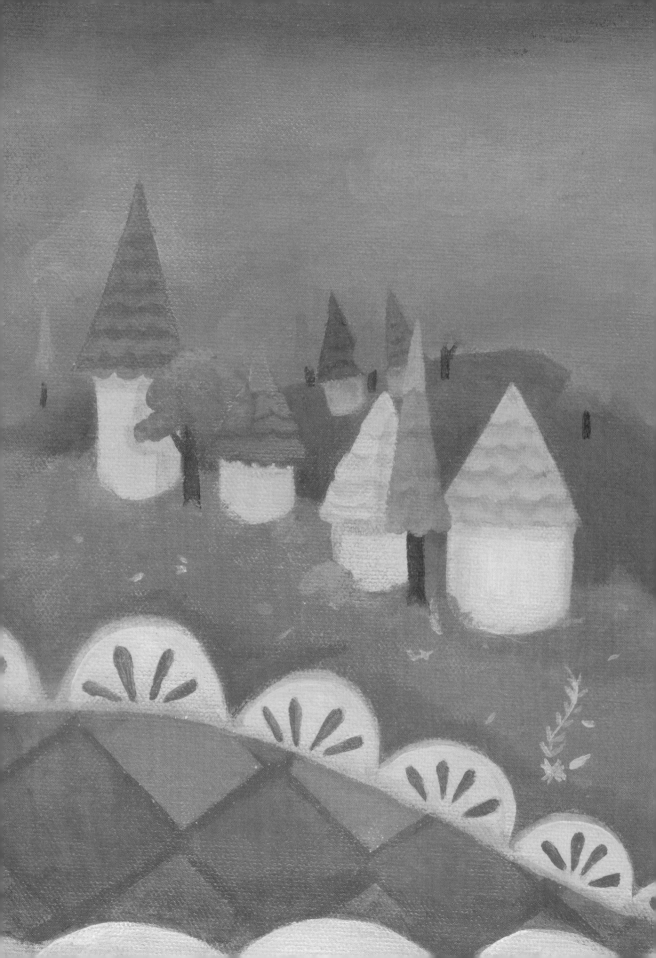

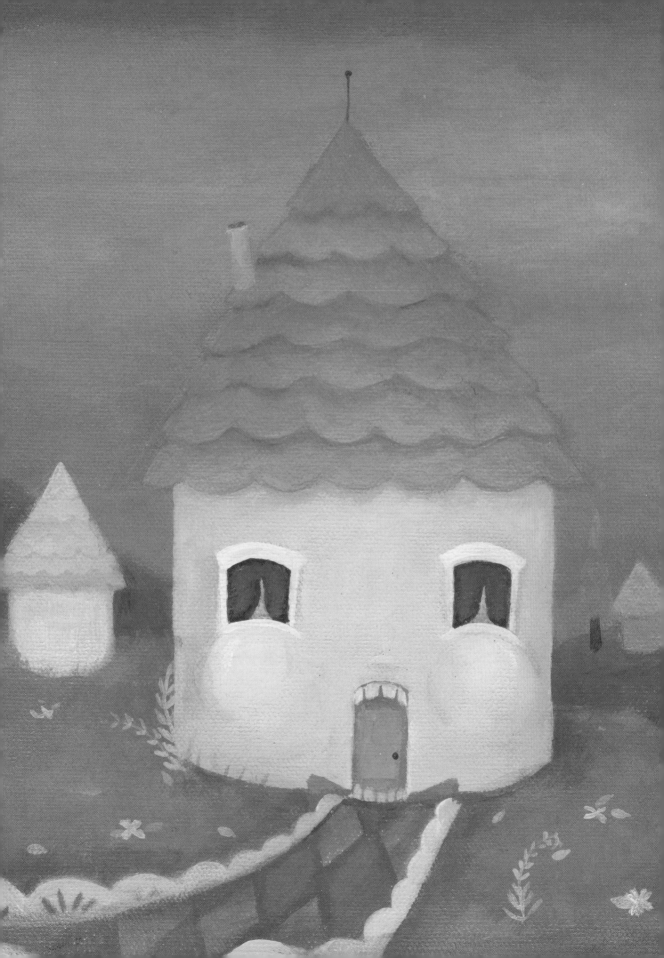

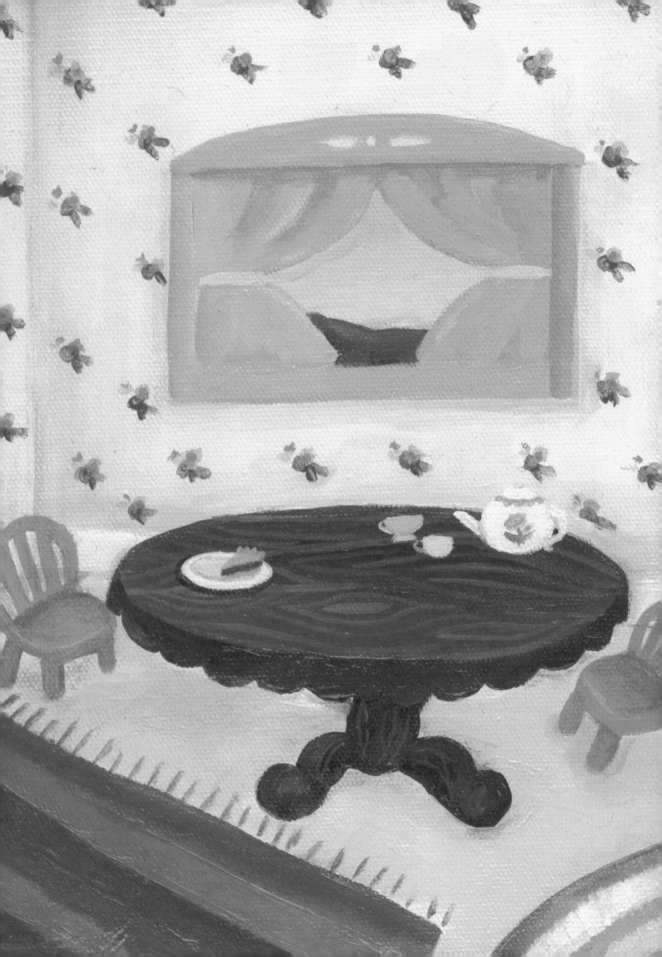

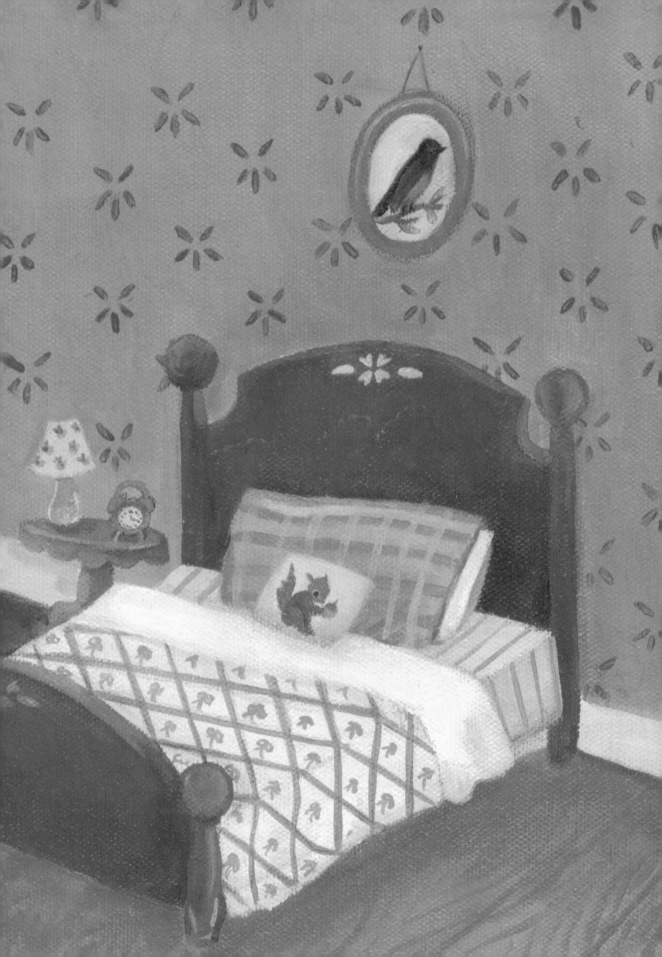

The Black Apple Theater

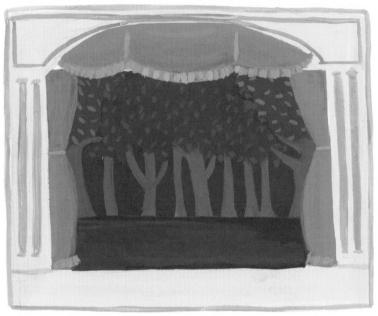

Paper dolls often are used to act out stories, but how many have their own pint-sized playhouse to perform in? This paper theater is easy to assemble, and because the pieces fit together with a system of interlocking slats (no glue or tape required), the whole shebang stores flat. You'll be able to use the scenes from The Scene Library as ready-made backdrops for your productions. I've also provided two sets of proscenium (a fancy word for the decorative bands along the top and sides of the stage) illustrations so you can adapt this theater to daytime or nighttime settings.

MATERIALS

Two 1" x 16" (2.5cm x 40.5cm) strips of heavy cardboard or mat board (to hold the side walls together at the top)

Two 10" x 10" (25.5cm x 25.5cm) squares of heavy cardboard or mat board (for the theater's side walls)

Two 2" x 16" (5cm x 40.5cm) strips of heavy cardboard or mat board (to support the stage floor)

One 1" x 15" (2.5cm x 38cm) strip of heavy cardboard or mat board

Proscenium illustrations (pages 81–85): Cut out top pieces, side column pieces, and small arch pieces (night or day version)

One 8" x 15" (20.5cm x 38cm) sheet of decorative paper (for stage floor)

TOOLS

Ruler

Pencil

Craft knife and cutting mat

Rubber cement (so you can easily switch the day and night proceniums)

Instructions

1. Place one 1" x 16" (2.5cm x 40.5cm) cardboard strip on the cutting mat. Using the craft knife, cut a ½" (13mm) long notch perpendicular to a long side and ½" (13mm) in from each end of the strip. The notches should be just thick enough to accommodate the thickness of the board you are using.

 Repeat with the other 1" x 16" (2.5cm x 40.5cm) strip. (These 2 strips should be identical, with matching notches on each end.) *a*

2. Place one cardboard square on the cutting mat. Using the craft knife, cut a ½" (13mm) long notch perpendicular to and 1" (2.5cm) in from each end of the top edge (labeled edge A in the illustration). Repeat with the other cardboard square. (These 2 squares should be identical.) *b*

3. At edge B of one cardboard square, measure with a ruler and lightly mark with a pencil 2 points 1" (2.5cm) from the bottom edge: one 1" (2.5cm) from the right side and another 3" (7.5cm) from the right side. Connect these 2 points.

 Repeat, measuring, marking, and connecting 2 more points on the left side of the square.

4. Using the craft knife, cut along each line. Each incision should be only as wide as needed to accommodate a 2" x 16" (5cm x 40.5cm) strip, and the fit should be as snug as possible. Widen the notch slightly if needed.

 Repeat steps 3 and 4 with the second square. Each cardboard square should now have two ½" (13mm) long notches near the left and right top corners (edge A), and two 2" (5cm) interior incisions parallel to the bottom edge (edge B). *c*

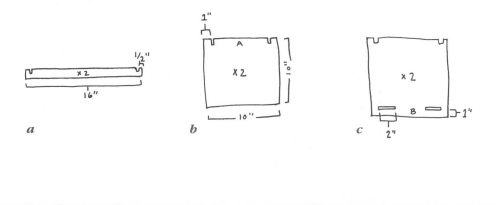

5. Arrange the 6 chosen proscenium illustrations (top pieces, left and right columns, and small arches) on a flat surface, referring to the illustrations for guidance. Using rubber cement, adhere sides A and B of the proscenium top. Allow the adhesive to dry.

 Adhere the proscenium top to one of the 1" x 16" (2.5cm x 40.5cm) strips, *notched side down,* aligning the bottom edges of the 2 pieces to completely cover the strip. Allow the adhesive to dry. Using your knife, create notches in the proscenium top illustration to match the notches in the strip. *d*

6. Adhere the blank tab at the bottom of one arch to the back side of the top of one column. Repeat with the other arch and column. Allow to dry. *e*

 Hint: The side tabs should be facing in *opposite directions* when the 2 columns are oriented correctly.

7. Adhere the tab along the left side of the left column to a side edge of one 10" x 10" (25.5cm x 25.5cm) cardboard square, with the illustration facing out. Repeat with the right column and the remaining square.

Allow to dry. (These columns decorate the front of the stage, facing the audience.)

8. Sit both sides of the theater upright on your work surface (notches on top), and match the notches farthest from you with the corresponding notches on the plain 1" x 16" (2.5cm x 40.5cm) strip; match the notches closest to you with the notches on the other strip (adhered to the proscenium top), with the illustration showing. (These top pieces should fit snugly into place.)

9. Slide the ends of the two 2" x 16" (5cm x 40.5cm) strips into the four 2" (5cm) interior incisions in the side walls to span the "floor" of the theater. The whole structure should now be shaped like ... a theater!)

10. Place the 8" x 15" (20.5cm x 38cm) sheet of decorative paper over the 2" x 16" (5cm x 40.5cm) strips. This paper creates the stage floor of the theater.

 You're now done assembling The Black Apple Theater! Take a step back and give yourself a standing ovation. Turn to page 86 to discover how to transform your favorite paper dolls into puppets.

PROSCENIUM

d ARCH COLUMN *e*

ODDS & ENDS

✳ If you'd really like to get fancy with your toy theater, try creating some small fabric curtains. This would add dimension and charm to the tiny stage!

Photocopy at 125% magnification

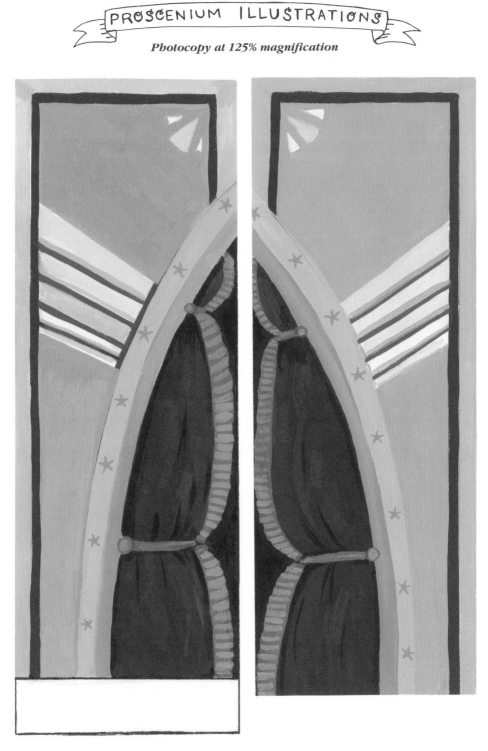

night proscenium top side B *night proscenium top side A*

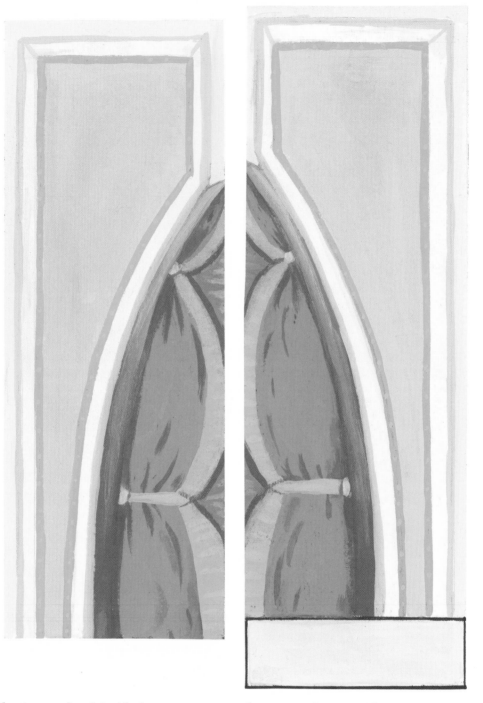

day proscenium top side A *day proscenium top side B*

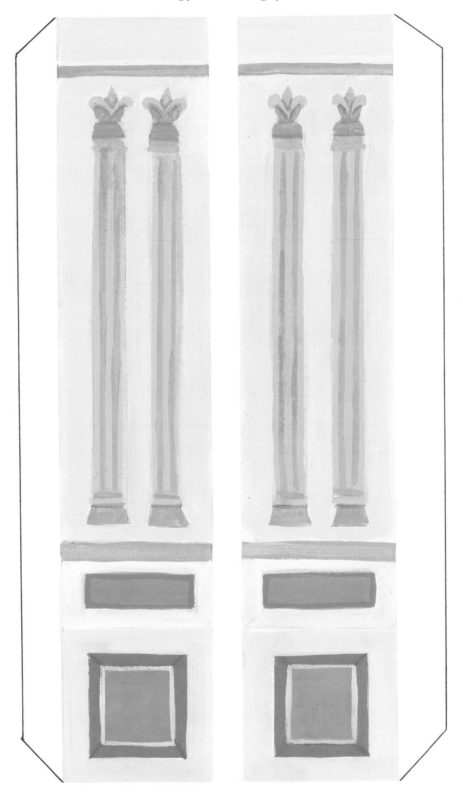

day proscenium columns

night proscenium columns

night proscenium arches

day proscenium arches

Paper Doll Players

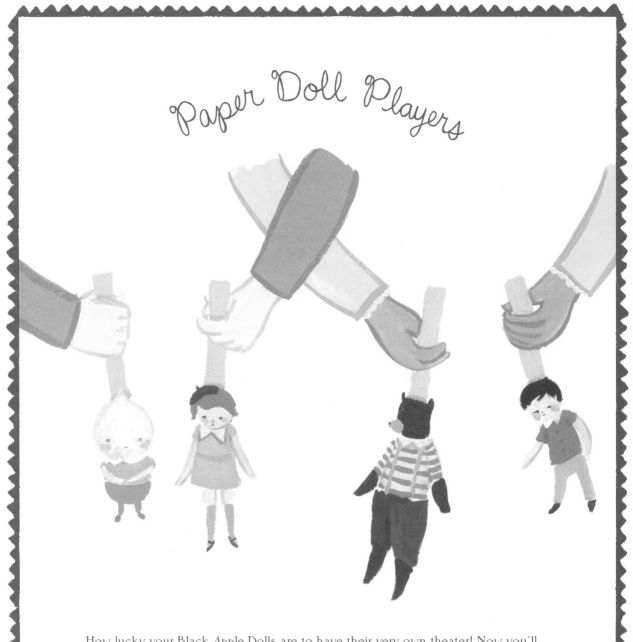

How lucky your Black Apple Dolls are to have their very own theater! Now you'll learn how to easily transform the dolls into puppet actors, which you can manipulate from above the theater. Here you're welcome to use any of the Black Apple Dolls, or, if you'd like, you can incorporate the custom dolls from the Paper You collection (page 94). Using a couple of simple materials, they'll be ready—in a snap—to act out the comedies and tragedies of your own devising.

MATERIALS

Selected paper dolls from the Black Apple dolls (page 17–32)

Standard wooden Popsicle sticks or tongue depressors (as many sticks as you have paper doll actors in your play)

Selected scene from The Scene Library (page 65–77)

Small binder clips (or small clothespins)

The Black Apple Theater (page 78)

TOOL

Rubber cement

Instructions

1. Place a paper doll *facedown* on your work surface. Apply rubber cement to about 1" (2.5cm) of one end of a Popsicle stick, and adhere it to the back of the paper doll's head, extending the stick upward, away from the body, as shown in the illustration. (This will allow you to manipulate the paper doll puppet from above, puppet-style.) Allow the adhesive to dry. Repeat for the remaining cast of paper dolls. *a*

2. Using binder clips, secure the scene to the plain 1" x 16" (2.5cm x 40.5cm) strip at the back of The Black Apple Theater. Make sure the 2 sides of the scene line up correctly. *b*

3. Place the entire theater on a table or on a similar sturdy flat surface, and seat your audience where they'll have the best vantage point for the show.

a

b

ODDS & ENDS

✳ Get creative! Make up a story of your own and figure out all the fun particulars. Things like this: What kinds of voices should you use for the characters? How many costume changes should there be? What is the best way for paper thespians to avoid being pelted with tiny tomatoes?

＊ ★ ＊

MAKING PAPER DOLLS
OF YOU AND YOURS

Have you ever wondered what a tiny paper doll version of yourself would look like? What your wardrobe might resemble at 1/100th scale? What your hair would look like in two dimensions (really flat!)?

Even if these thoughts have never crossed your mind, I'll bet a paper you would be cute. That's why this section is full of customizable dolls and clothes!

On the following pages, you'll find hundreds of possible combinations to make a paper doll version of your very own self. Choose a (mostly) blank doll, match it with a fetching hairstyle, and select and create a doll-sized closet's worth of paper garments. Then comes the really fun part: Customize the doll (and its attire) using pens, paint, and whatever other decorations or supplies you like. I suggest some materials on the next few pages, including a number that I used to create the illustrations in this book. But keep your mind open, and feel free to use whatever you're comfortable with and have handy!

After you make a Paper You, you can make paper versions of everyone you know—your mom, pop, root beer dealer, mail carrier, or favorite president. Some of my own favorite famous friends are featured on page 96.

MATERIALS for CUSTOMIZING

Here I thought it would be fun to share some of my favorite mediums, and to let you know what, in my opinion, their best uses are when it comes to creating and embellishing items from the book. Since I used these mediums to create most of the book's illustrations, I've figured out a few tricks and tips! All these mediums are straightforward, easily available, and (I hope) unintimidating. I encourage you to try them out, but I want to emphasize that I hope you will use what you feel comfortable with, too (if you're already a whiz with colored pencils, definitely incorporate those into your doll customizations)! No matter which mediums you use, you're going to make some cool custom dolls that are 100 percent you!

Pen Ink

Pens are wonderful, portable, and versatile—and chances are you've already got quite a few hiding beneath your couch cushions and stashed in your desk drawer. I like acid-free, felt-tip pens that come in varying thicknesses (although I favor the good ol' 0.35mm, myself). The different thicknesses can produce widths from a wispy thin line to a stout rivulet of ink. Any art store will have a large selection of brands, types, and colors.

Another type of pen I like to use is the gel pen—a big favorite with children because of the gleaming, odd-colored metallic, pearl, and piercing fluorescent color choices. Gel pens are available in an impressive spectrum of colors and types, including light-colored opaque inks that are fun to use on top of darker areas of color.

Best for:

* Details, such as freckles and eyeglasses
* Sharp graphics, such as rigid stripes
* Small, defined patterns
* Lettering

Fluid Ink

Fluid ink is sometimes called drawing ink, India ink, or artist's ink. No matter what the name, almost all fluid ink comes in sweet little jars or pots. My favorites are the Winsor & Newton drawing inks, but I might just favor them because of the beautiful, old-timey packaging! I like to use inks with a small brush, although many can be used with a dip pen as well. Most can be easily thinned with water for a more translucent effect, or built up in a few layers for a brighter, more vivid application.

Best for:

* Rosy cheeks
* Delicate or subtle washes
* Shading
* Abstract patterns

Paint

Acrylic paint is one of the most ubiquitous art supplies. It can be found, in some form or another, at every large variety, craft, and art store. This is the medium I use the most in my work, and I use all sorts of it, from the premixed colors of inexpensive craft paints to the premium, heavily pigmented art acrylics. Acrylics come in pots or tubes, and are applied with brushes of different sizes. This medium varies in opacity, and as a general rule, unless the paint is specifically formulated to be especially opaque (like Cel-Vinyl), the pricier the paint, the more opaque it will be. If you desire ultimate opaqueness, you'll want to give gouache (an opaque watercolor paint) a try. Last but not least, remember that paper isn't always heavy enough to handle thick applications or layers of

paint, so some buckling of the paper might occur. It's best to brush some paint on the paper you're planning to use to see how well it absorbs the paint.

Best for:

- ✳ Covering larger areas (such as all or part of a shirt or dress) with bold color
- ✳ Opaque details
- ✳ Painterly patterns, such as a large floral motif

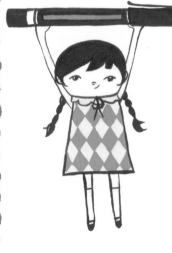

Marker

We're not talking about your regular ol' Magic Markers from elementary school, although those might be just the ticket, if you have some handy. These fancy-pants markers come from the art store and are used by illustrators, comic artists, and other professionals. They come in a spectrum of sophisticated colors, can be found in thick or thin versions, and some are even blendable. They can also be layered to create neat overlapping effects. The only thing to really watch out for with these (besides the oft-accompanying fumes—be sure to use them in a ventilated area) is that some brands bleed through to the back of the page you're working on—so just keep an eye on that and protect your work surface.

Best for:

- ✳ Filling in medium-sized areas, such as a hat
- ✳ Thick or thin stripes of vivid color (the width depends on the marker's tip, of course)
- ✳ Patterns (use with a ruler for structured patterns, such as plaids, or without a ruler for freehand designs)

CREATE A PAPER YOU

Now that you're acquainted with materials you can use to personalize a paper doll, let's get started. Begin by picking out a basic doll (pages 97–112) that most resembles you. These customizable dolls are sweet little blank slates that can be made to resemble pretty much anyone you know. Then, think about a few identifying characteristics that you'd like to translate onto paper. Maybe it's eye and hair color, a favorite sweater, or jaunty cap. The oh-so-adaptable Paper You collection of custom clothing on pages 113–130 will make it easy to dress yourself for success.

I thought it also might be helpful to make a diagram or two pointing out the particulars of using the clothes and materials to personalize a paper doll. And whose persnickety tastes and quirks do I know better than my own? Check out my one-of-a-kind Emily Doll, opposite, and a couple examples of paper doll-ified luminaries on the next page to learn how to create a doll in your own (or anyone else's) image.

EMILY DOLL

I can almost always be found wearing a beret. I painted this blank beret a nice teal, but there are several precolored ones to choose from in Etceteras for Everyone (page 128).

The sprinkling of freckles (just a few jots with a sepia pen) was essential.

My hair is a sort of "bell" shape, so I modified one of the paper wigs on page 121 just slightly (using black ink to emphasize the flip at the ends). I used an undiluted pot of black ink with a small brush to color the wig.

A white blouse is indeed classic, but I usually prefer a print. I created this little geometric floral print with a tiny brush and acrylic paint (although fine-tip markers or colored pens would've worked well, too).

If forced to choose, I'd have to say that red shoes are my very favorite sort of footwear. I sketched these out first, and then painted them in with fetching vermillion acrylic paint and a small brush.

My eyes are a greenish hazel, so I added that tiny detail using a fine-tip marker. I also added my usual thick black eyeliner, which was created easily with just a tiny dash of black pen.

My lips are a very pronounced heart shape, and sometimes I like to play them up with a coat of crimson. A little paint did the trick.

I fashioned a "lace" look on one of the blouses from the Grown-up Gals' Shirts (page 114) by adding a line of scallops around the collar.

Gray is (in my opinion) the very best neutral, and a gray pencil skirt has become my skirt staple. This miniature version comes straight out of the Grown-up Gals' Skirts closet (page 115), with no tweaks or changes.

Black knee socks are another tried-and-true fashion choice. I added these simple ones to my doll by filling in the existing socks with opaque black ink.

It's easy to make a doll that looks like just about anyone using the customizable dolls, clothes, and accessories in this section. Here are two pint-sized versions of my favorite historical heroes.

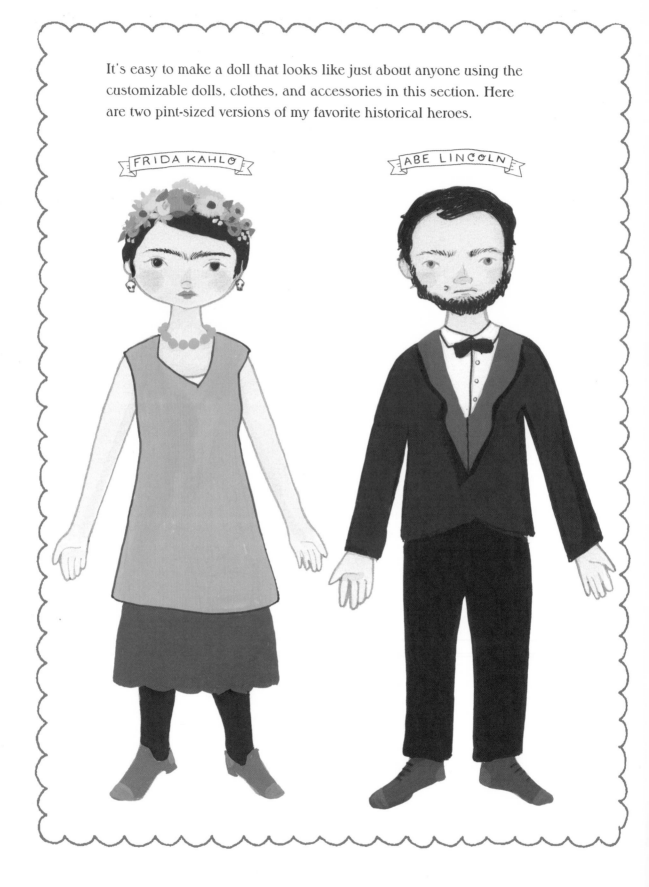

FRIDA KAHLO

ABE LINCOLN

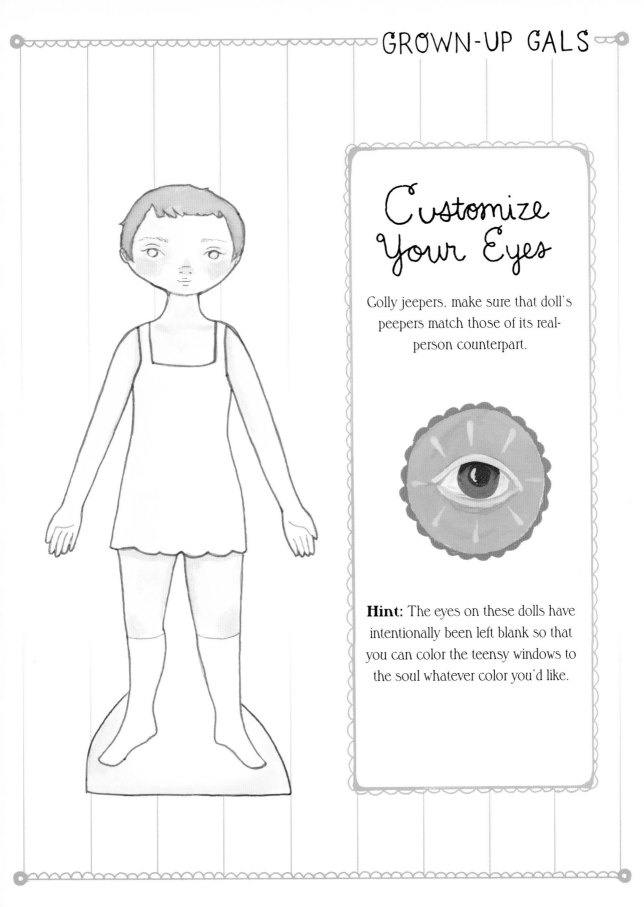

Customize Your Eyes

Golly jeepers, make sure that doll's peepers match those of its real-person counterpart.

Hint: The eyes on these dolls have intentionally been left blank so that you can color the teensy windows to the soul whatever color you'd like.

Socks Appeal

Socks are my very favorite accessory, so, I think it's worth seriously considering which pair of permanent socks to put on your paper doll's tootsies.

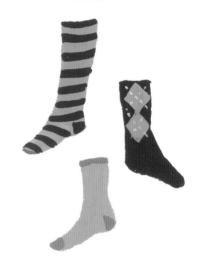

Hint: Vertical and horizontal stripes are simple and whimsical choices— and easy to achieve using a marker with a nice sharp tip. Argyle can be created with a row of tiny diamonds!

Gentlemen's Coiffures

On page 121 you'll find a plethora of paper wigs. But if the basic hair on these dolls just doesn't quite fit, you can create coifs just for them. Think about what they might like!

Hint: The paper wigs are meant to be at least semipermanent, so you'll want to trim them out and then adhere them directly to the doll using rubber cement so that you can remove the wigs and restyle your doll's hairdo as you like. For permanent placement, use regular all-purpose glue.

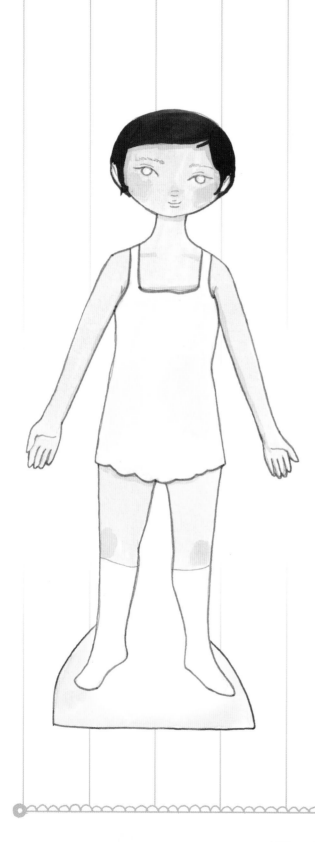

Girly Coiffures

On page 121 is a doll-sized "wig store," so don't worry if this doll's hair isn't perfect—you'll be able to pick out a wig that's just the ticket.

Hint: If you like, add a little pizzazz to your 'do! Use an opaque pen to draw a tiny bow, clip, or headband onto your doll's hair or wig.

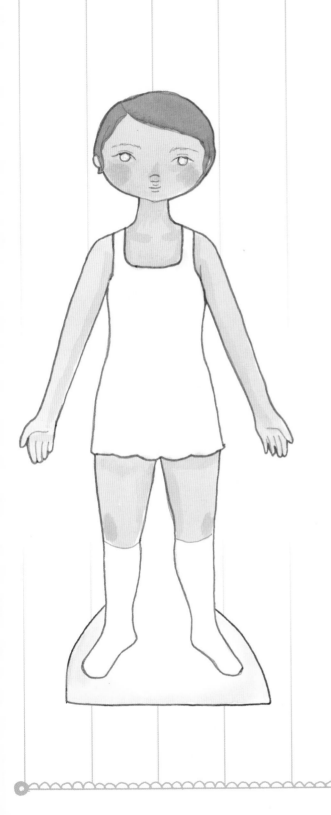

The Illustrated Man (or Lady)

I can't imagine a more delightful task (or a better use for a magnifying glass) than filling in a slew of tiny tattoos. So if your doll needs inking, hop to it!

Hint: For lettering, a fine-tip pen in black or deep blue will do the trick nicely.

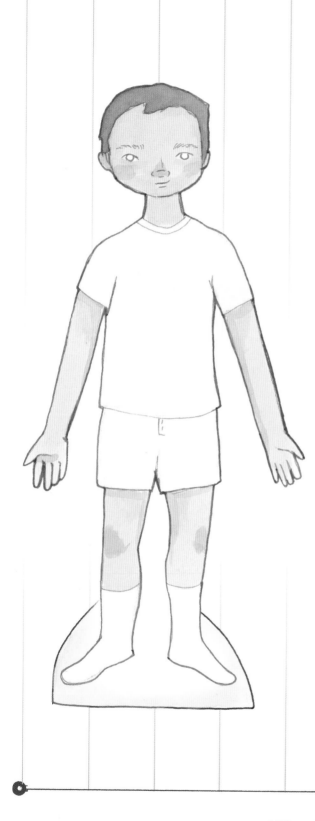

Winsome Whiskers

Some fellas sport a mustache or beard, and you can easily add a miniature Fu Manchu or a dapper handlebar to your doll.

Hint: Try using a slender paintbrush, or a marker in a just-right hue, to bewhisker this paper dandy.

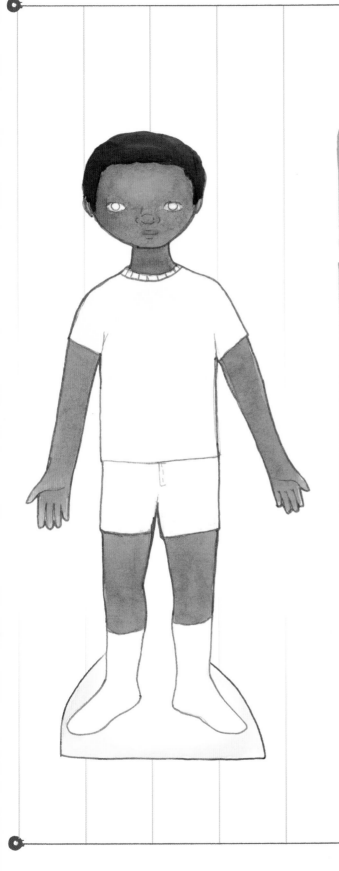

Fancy Footwear for Fellas

Shoe choice might say more about people than almost any other sartorial decision. Are they practical? Elegant? Insane? I'll leave that up to you.

Hint: Lightly sketch out the general shape first, so you can get it just right. I'd use paint or ink to color the shoe, and a few dashes of pen will lace them up in a snap!

Fancy Footwear for Ladies

How best to shod the doll's dainty soles—1920s pumps? Sensible flats? Combat boots? You decide!

Hint: Though black and brown are the shades most common for shoes, I prefer brighter colors! You might be surprised at just how many outfits go with red or blue shoes.

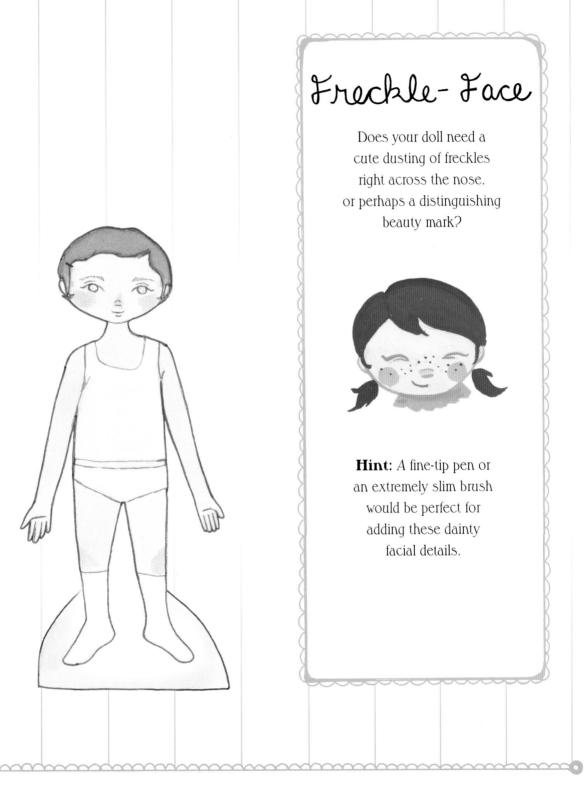

Freckle-Face

Does your doll need a cute dusting of freckles right across the nose, or perhaps a distinguishing beauty mark?

Hint: *A fine-tip pen or an extremely slim brush would be perfect for adding these dainty facial details.*

Band Tee

The idea of the undershirt as a permanent band tee, a layer that lurks beneath every outfit declaring your loyalty and devotion, is pretty rad (if a little . . . um . . . intense). Turn the amp up to eleven and try to suss out which band deserves to be, literally, closest to your doll's heart.

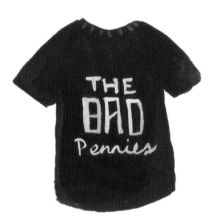

Hint: If you decide on a very dark color (like black or navy) for the shirt, opaque gel pens are the easiest way to layer lighter text and designs on top.

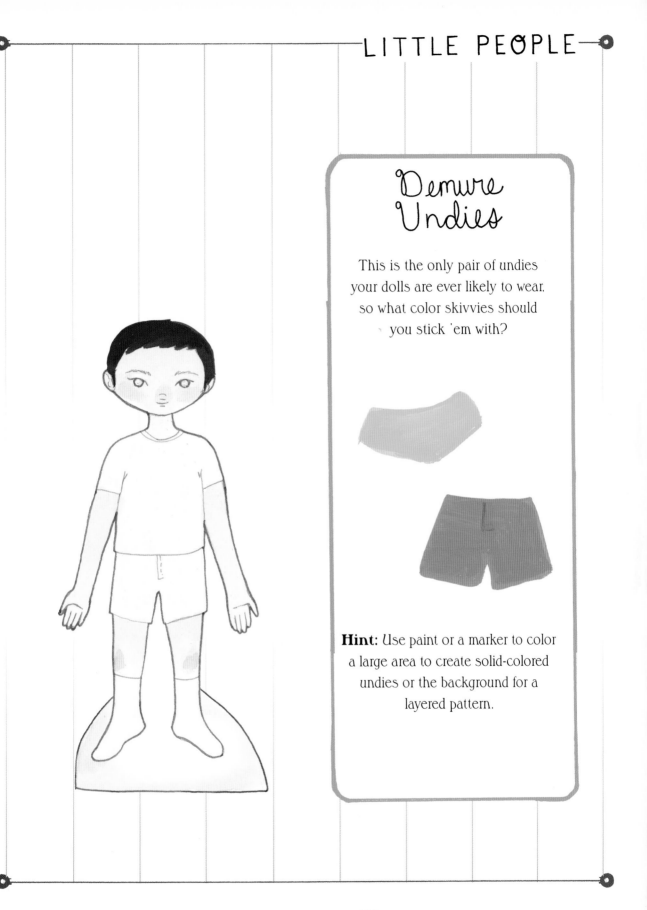

Demure Undies

This is the only pair of undies your dolls are ever likely to wear, so what color skivvies should you stick 'em with?

Hint: Use paint or a marker to color a large area to create solid-colored undies or the background for a layered pattern.

Fun Undies

Plain red, blue, or pink too boring? Adorn your undershirt and bottoms with fetching patterns, such as plaids, polka dots, or classic stripes.

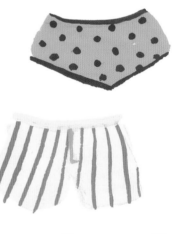

Hint: If you're nervous about keeping your patterns straight, a ruler will help—especially when creating plaids or stripes!

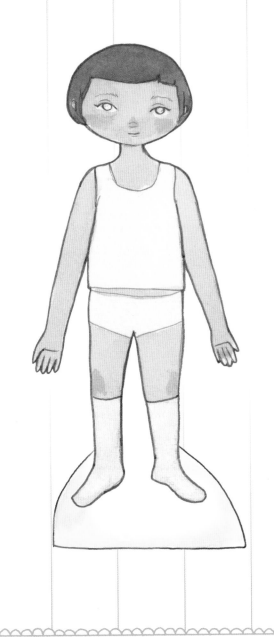

All Made Up

Does your two-dimensional paper person require a signature crimson lip or dramatic 1960s eyeliner? How about some extra-rosy cheeks?

Hint: Use diluted ink and a small brush. Try peach or pink on the cheeks, red or mauve on the lips, and any color under the sun for eye-catching eye shadow.

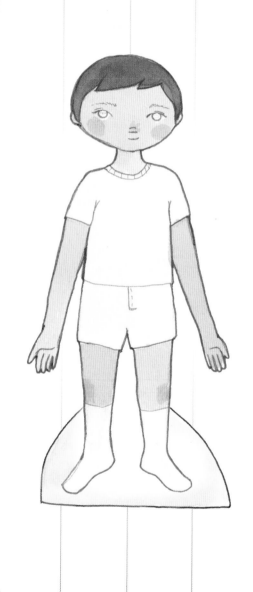

Hey, Four Eyes!

Is your doll a little nearsighted? There are hundreds of alluring spectacles in this world, so give your little myopic pal some fancy frames. Cat's-eye? Horn-rimmed? Heart-shaped? It's utterly up to you!

Hint: Sketch out the glasses in pencil first—gauging where the frames and bridge should fall is trickier than you might think.

A Brilliant Disguise

Sometimes a paper doll needs to embrace his or her inner bandit (or superhero . . . or *luchador*!). When that time comes, a mask is an easy enough way to go undercover.

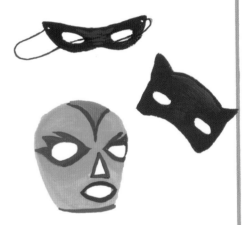

Hint: Sketch out your mask first (as with glasses, it can be hard to gauge where eyeholes and such should go) and then use colors or classic black to craft a doll-sized disguise.

Fancy Wearables

Lots of folks have a piece of jewelry or two that they instinctively put on each morning, no matter what outfit they're wearing. Because your doll (probably) can't think, pencil in her baubles and bangles for her.

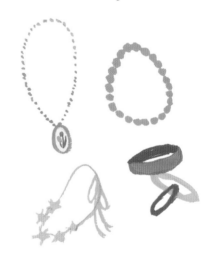

Hint: Opaque paint will make for nice beads and bracelets. Try using the handle of a small brush, or a toothpick dipped in your choice of paint, to make nice uniform dots of color.

CLOTHING & ETCETERAS FOR EVERYONE

Because I wanted to give you as many variations and options for customization as possible, I crafted these collections with the color copier in mind. Paper doll clothes work wonderfully when photocopied onto regular copy paper, and you should use this to your advantage! The customizable elements (clothes, hair, and accessories) found on the pages that follow are printed back to back, so I highly recommend photocopying these pages if you have access to a copy machine. This will ensure that you get to use every single tiny shirt and scarf, without cutting through any garments on the other side of the page! I suggest that you make multiple copies if you can, so that you can experiment as freely as you'd like with pens, paint, ink, and other decorations.

When you thumb through the clothes, wigs, and accessories, you'll notice that some have been shaded with a subtle "ghostly" whitewash rather than having been colored in fully like the others. I did this partly because some of them look quite fetching in simple white. But mostly it was because while adding patterns and embellishments certainly helps personalize a piece of clothing, I thought that in some cases you'd like to be able to choose the exact color yourself. Also, I could never guess what madcap color choices some of your creative brains might come up with. I've also included a little library of fabric patterns that can be used on the customizable clothing. Ranging from the practical (mock-corduroy) to the fanciful (harlequin diamonds), these "fabric" swatches will come in handy when you want to jazz up a solid shirt or skirt.

Grown-up Gals' Shirts

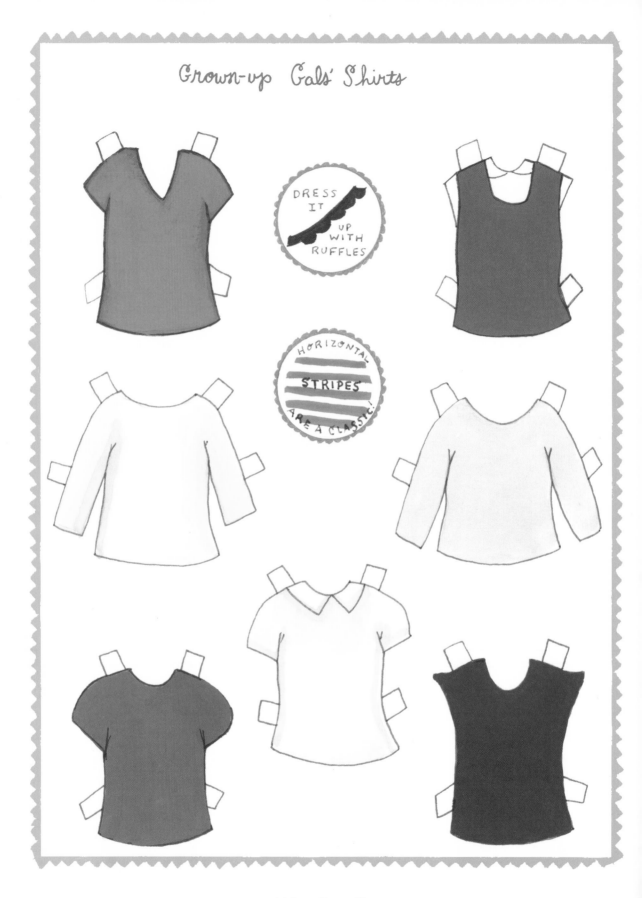

DRESS IT UP WITH RUFFLES

HORIZONTAL STRIPES ARE A CLASSIC!

Grown-up Gals' Pants + Skirts

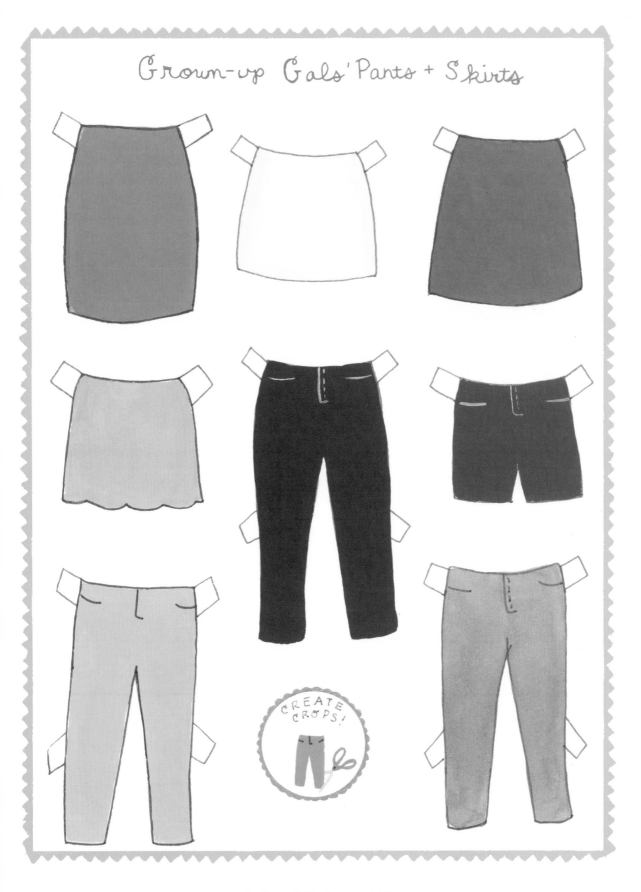

CREATE CROPS!

Grown-up Gals' Dresses

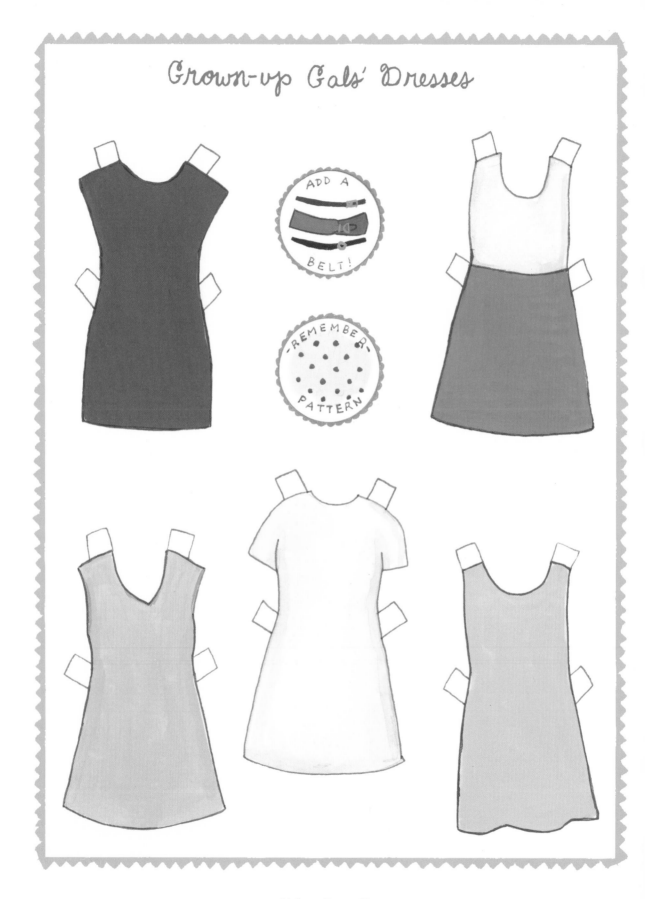

ADD A BELT!

REMEMBER PATTERN

Grown-up Gals' Jackets

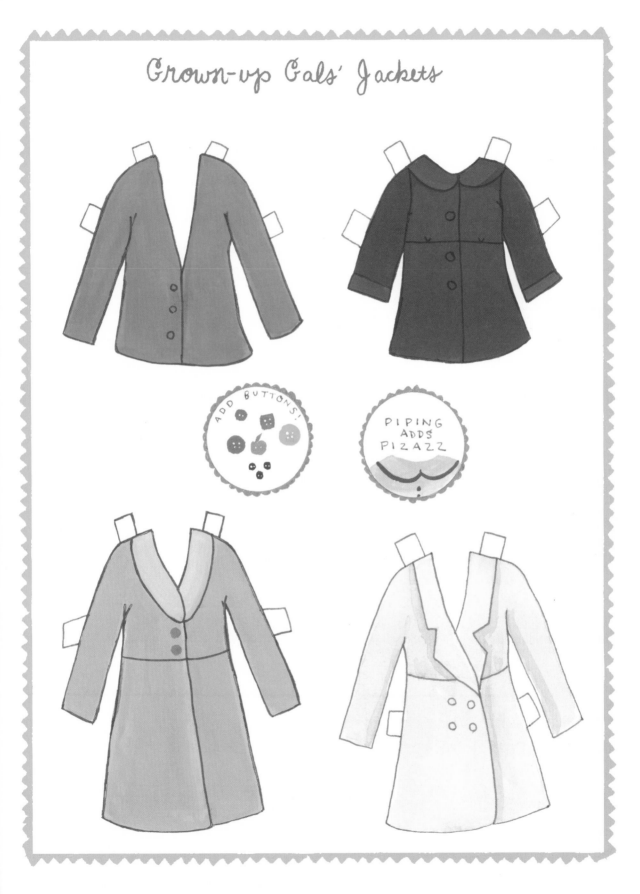

ADD BUTTONS!

PIPING ADDS PIZAZZ

Grown-up Fellas' Shirts

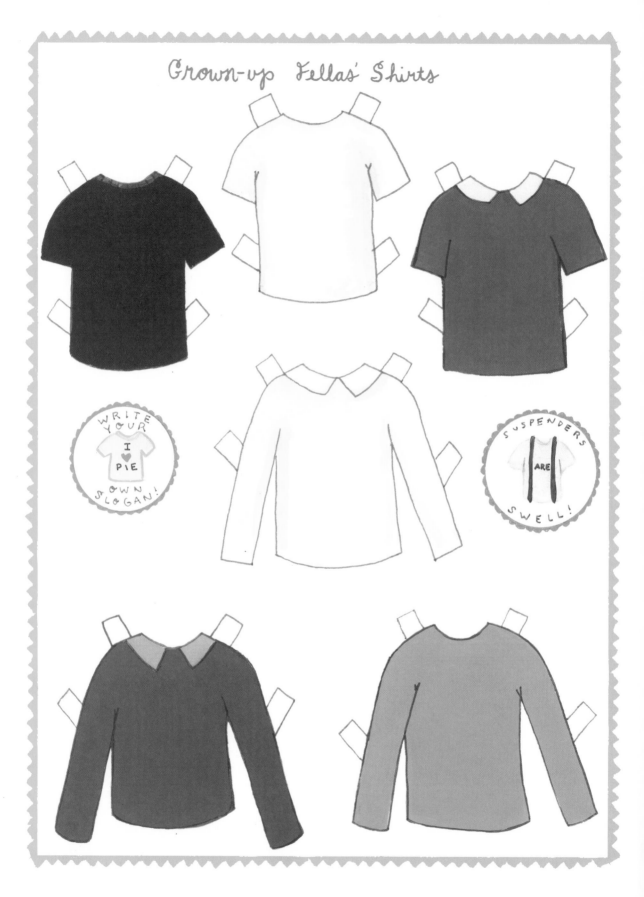

WRITE YOUR
I ♥ PIE
OWN SLOGAN!

SUSPENDERS
ARE
SWELL!

Grown-up Fellas' Trousers

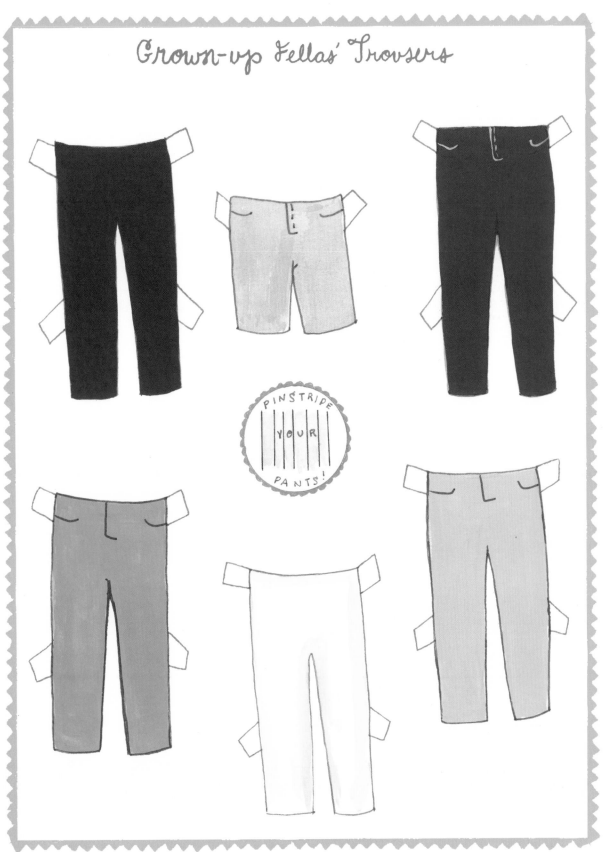

PINSTRIPE YOUR PANTS!

Grown-up Fella's Jackets + Sweaters

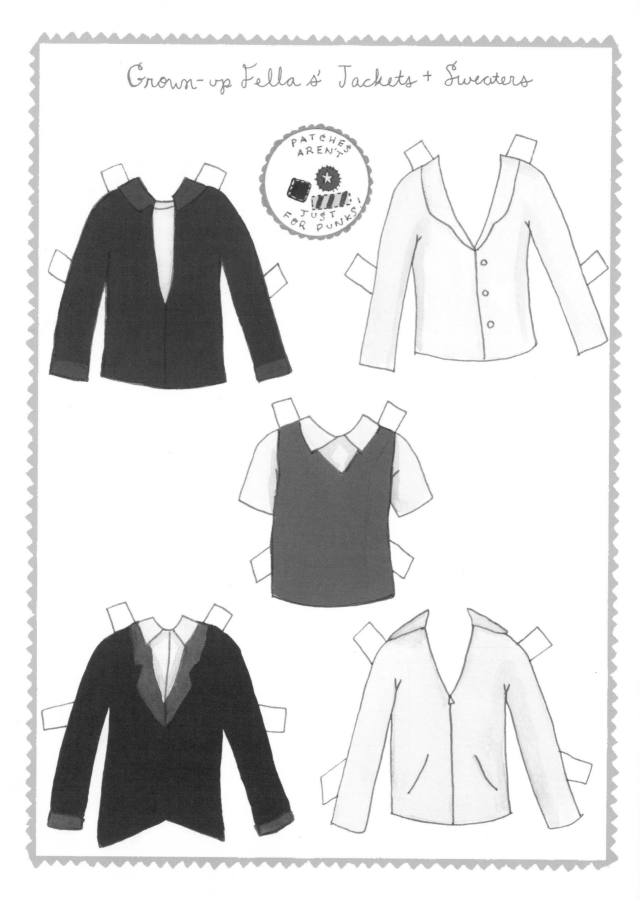

PATCHES AREN'T JUST FOR PUNKS!

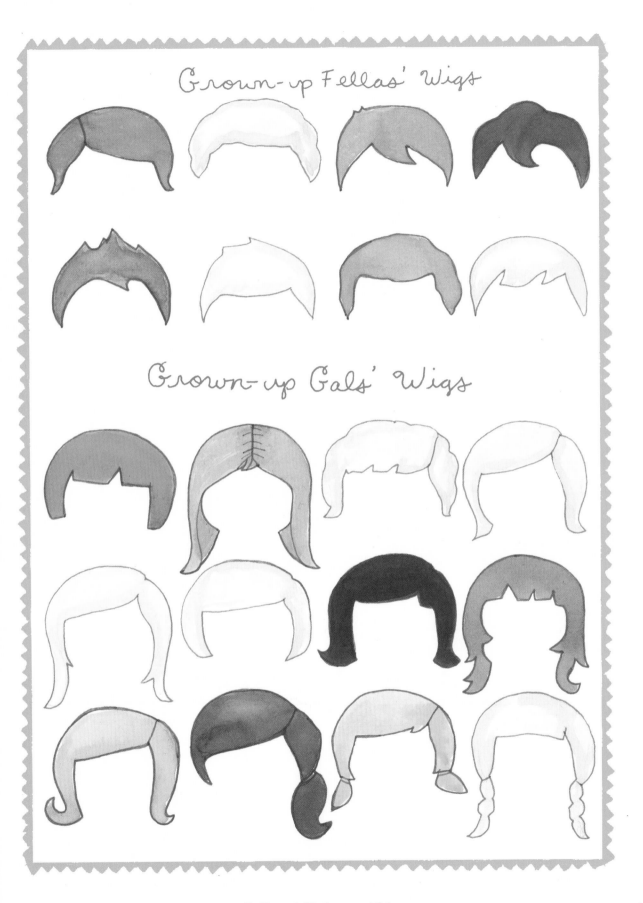

Grown-up Fellas' Wigs

Grown-up Gals' Wigs

Little Gals' Shirts

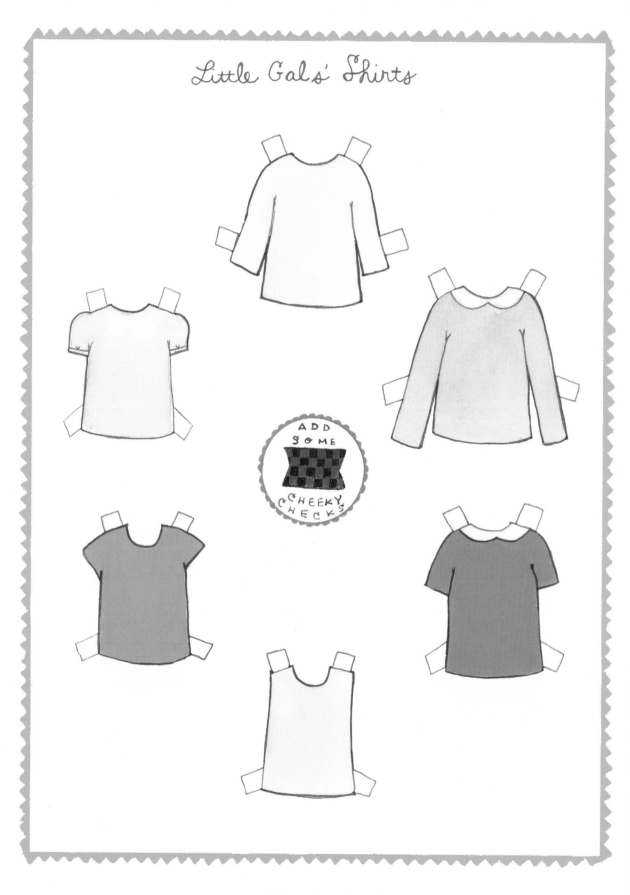

ADD SOME CHEEKY CHECKS

Little Fellas' Shirts

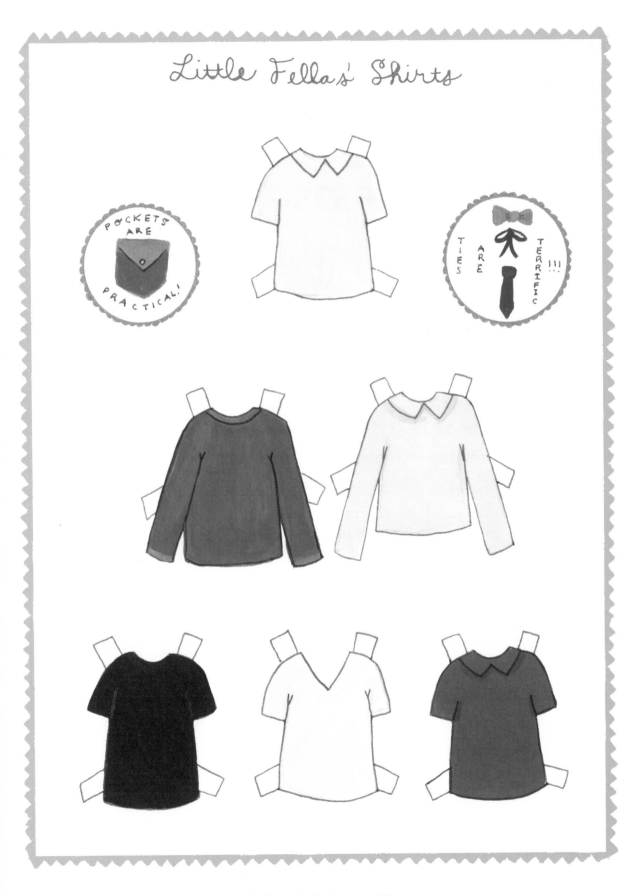

POCKETS ARE PRACTICAL!

TIES ARE TERRIFIC !!!

Dolls and Clothes **123**

Little People's Pants + Skirts

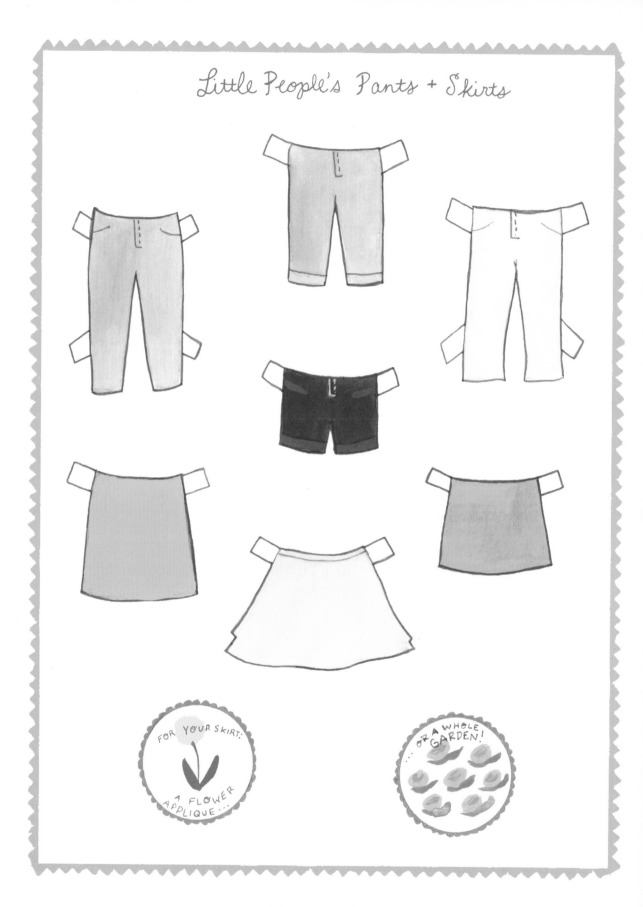

Little Gal's Dresses

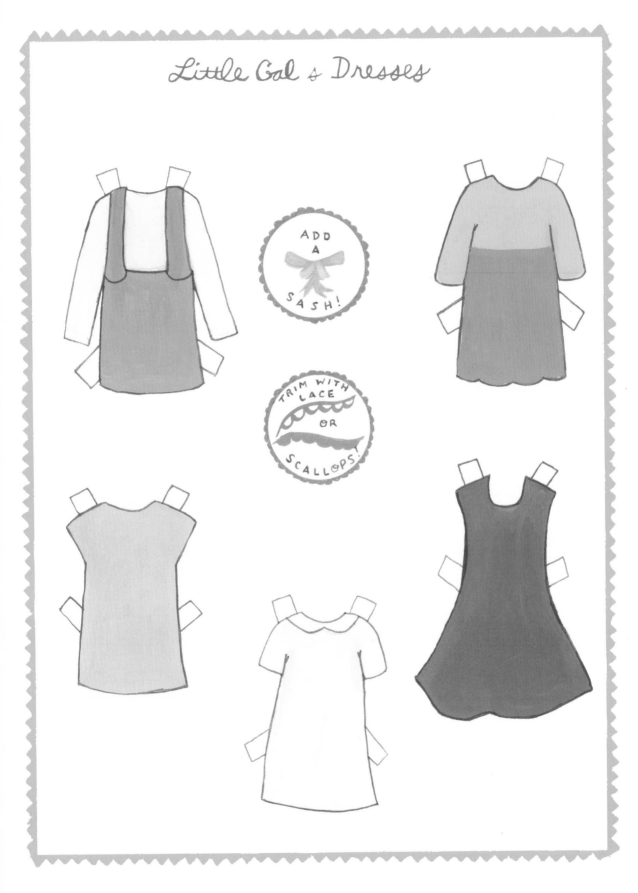

ADD A SASH!

TRIM WITH LACE OR SCALLOPS!

Little People's Sweaters + Jackets

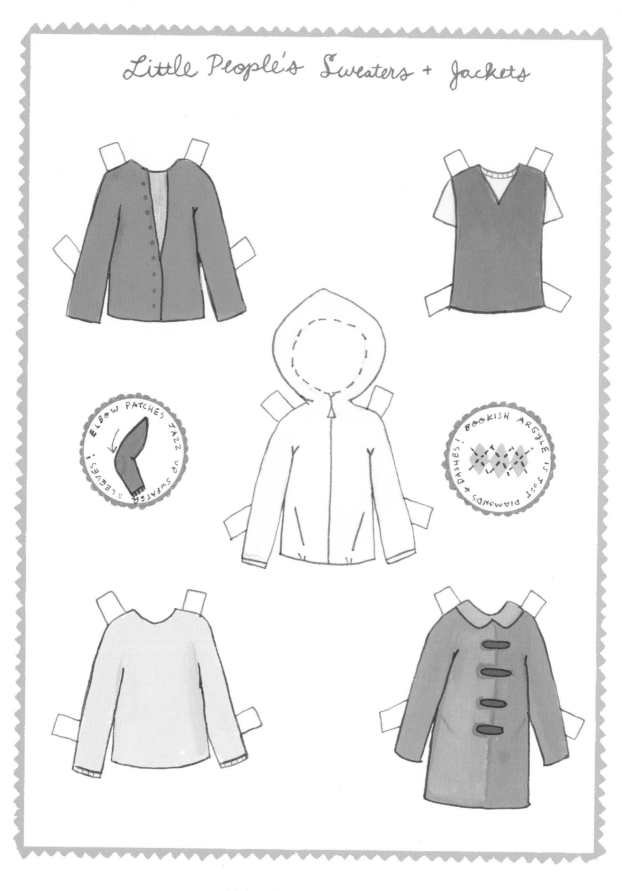

ELBOW PATCHES JAZZ UP SWEATER SLEEVES!

BOOKISH ARGYLE IS JUST DIAMONDS + DASHES!

Little People's Wigs

Etceteras for Everyone

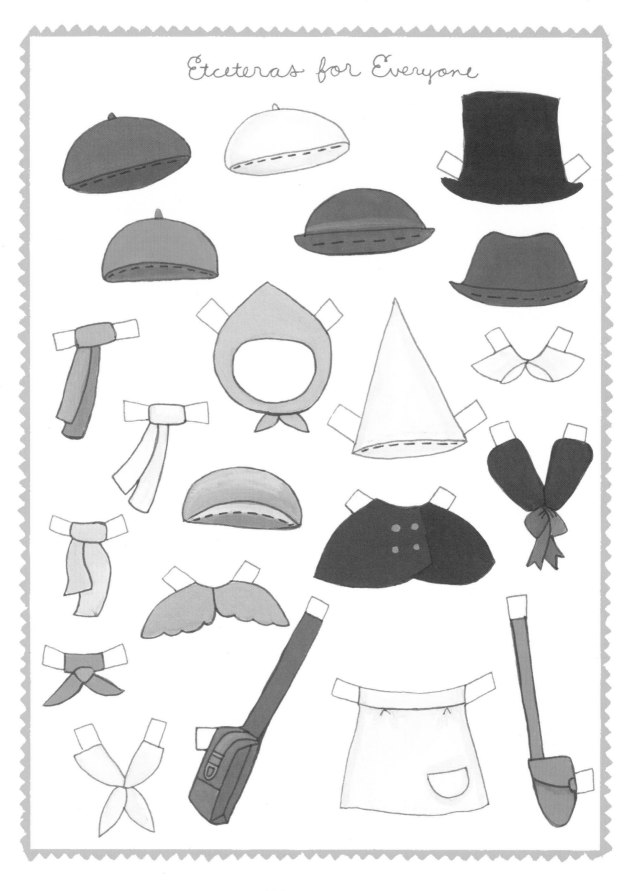

PATTERNS

Give life to plain clothing and accessories with fun fabric patterns!

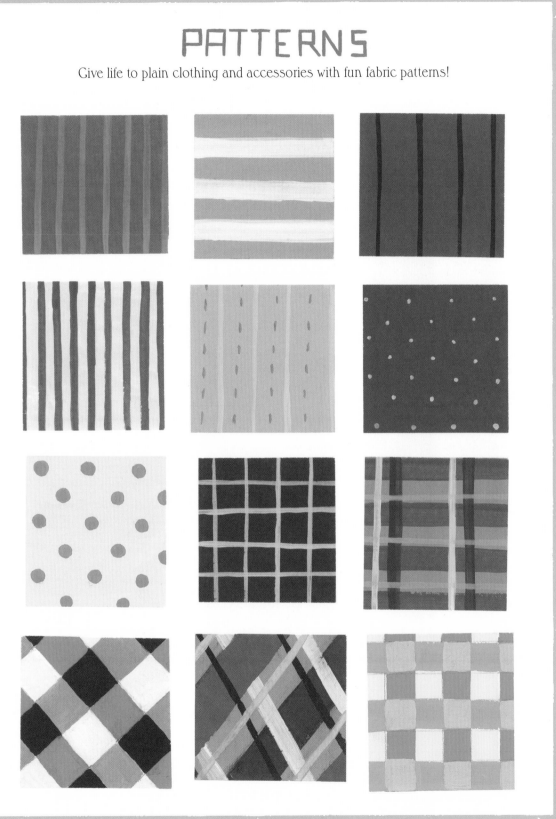

PATTERNS

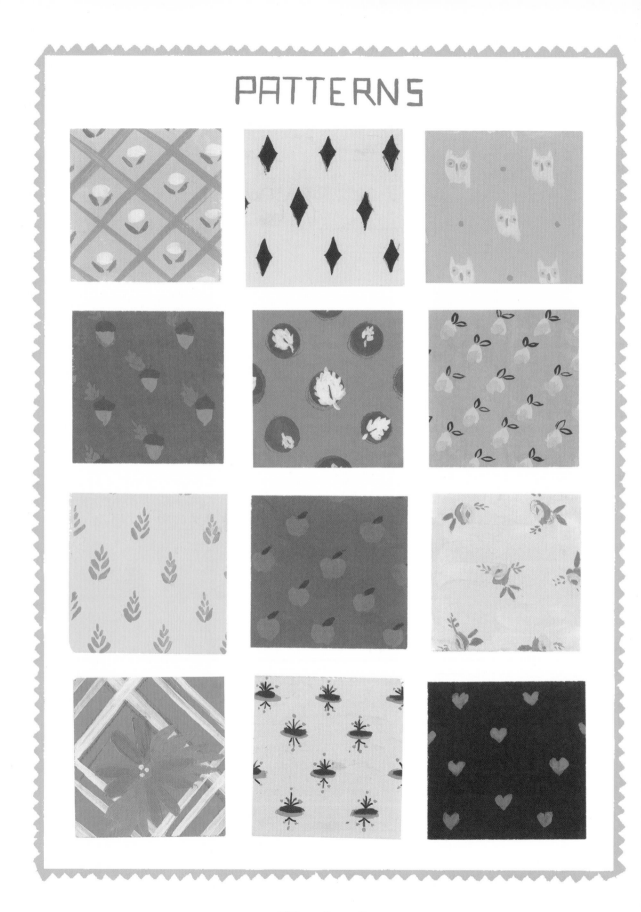

Do You...

☐ Have Glasses?

☐ Have an eyepatch?

☐ Have Freckles?

☐ Have a Beard?

☐ Have a Birthmark?

☐ Have a Tattoo?

If so, make sure the Paper You has one, too!

Family Portrait

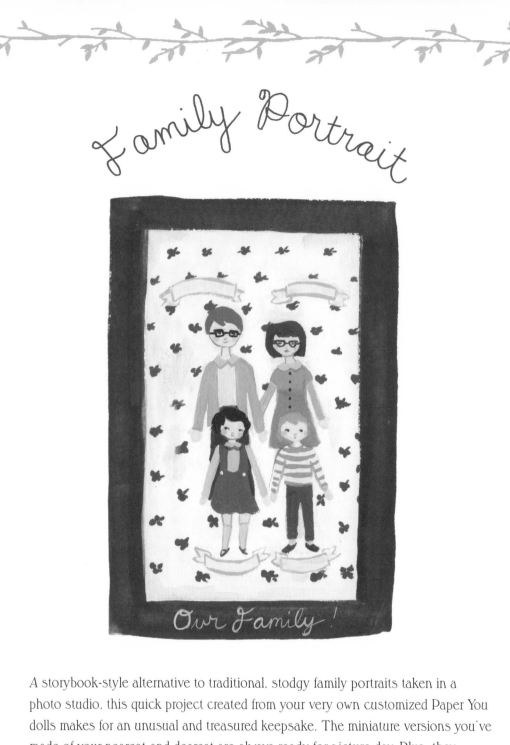

Our Family!

A storybook-style alternative to traditional, stodgy family portraits taken in a photo studio, this quick project created from your very own customized Paper You dolls makes for an unusual and treasured keepsake. The miniature versions you've made of your nearest and dearest are always ready for picture day. Plus, they don't have to worry about being stuck wearing an embarrassing sweater or having spinach in their teeth!

MATERIALS

Acid-free decorative paper, sized to fit the chosen frame (for the background)

Picture frame (8" x 10" [20.5cm x 25.5cm] or 11" x 14" [28cm x 35.5cm] will work best)

Paper You dolls representative of each family member

White or cream-colored acid-free paper for banners (optional)

TOOLS

Scissors

Rubber cement

Pencil

Instructions

1. Using scissors, trim your decorative paper to fit inside the frame.

2. Arrange the dolls on the background paper. When you're happy with their placement and spacing, adhere them with rubber cement.

 Hint: See page 94 for instructions on making custom dolls.

3. If desired, trace onto acid-free paper as many name banners as you need from the Name Banner Template below. Write in your family members' names and cut out the banners. Arrange the banners on the paper background as you like, and adhere them with rubber cement.

4. After the rubber cement has completely dried (approximately 5 minutes), place the "family portrait" into the frame. Hang it somewhere in your house where every visitor will be sure to admire your handsome family!

ODDS & ENDS

✳ For the portrait background I recommend the beautiful acid-free papers now available at craft stores (check the scrapbooking aisle) and online, at websites like the wonderful paper emporium Paper Source (www.paper-source.com).

NAME BANNER TEMPLATE

PROJECTS DIVERSIONS

AND

PART THREE

Paste

FURTHER CONTRAPTIONS AND CAPERS

It is a well-known fact that a person in ownership of a paper doll book must be in want of more things to do with those dolls. Of course, you can always just cut the dolls out and dress them up—that's all well and good. However, in this part of the book, I want to give those restless fingers of yours an assortment of further ways to play with the dolls and etceteras. If you're a person who wishes to go above and beyond with your Paper Doll Primer, then look no further.

Herein, you will find expanded and unexpected things to make and do with your dolls, including a flip book and a stop-motion film, and unusual ways to use and display them, like a magnificent mobile and your very own custom stationery.

Now, go play!

Armoire

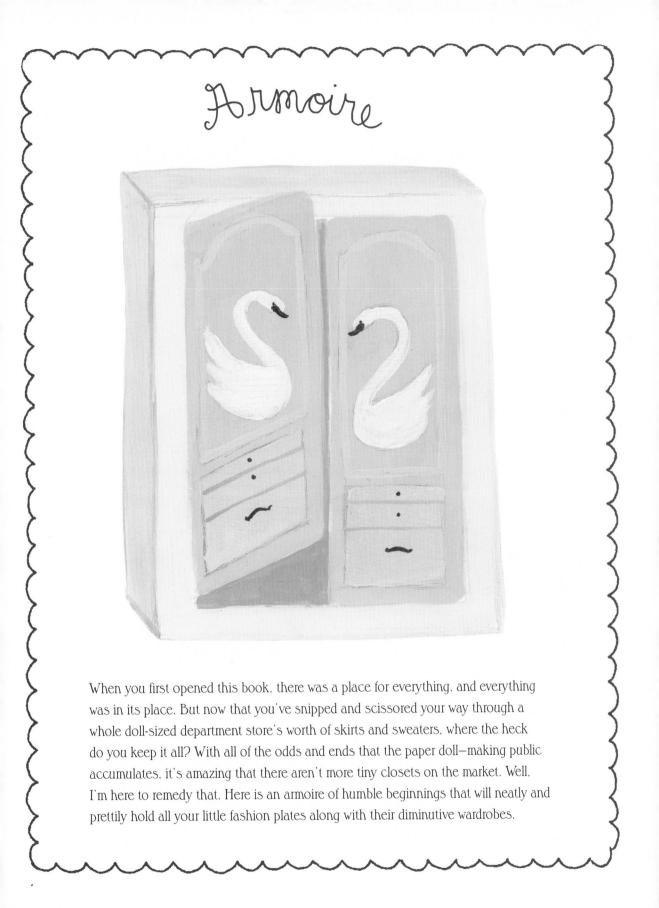

When you first opened this book, there was a place for everything, and everything was in its place. But now that you've snipped and scissored your way through a whole doll-sized department store's worth of skirts and sweaters, where the heck do you keep it all? With all of the odds and ends that the paper doll–making public accumulates, it's amazing that there aren't more tiny closets on the market. Well, I'm here to remedy that. Here is an armoire of humble beginnings that will neatly and prettily hold all your little fashion plates along with their diminutive wardrobes.

MATERIALS

Medium-weight paper, such as gift wrap (enough to cover the box on all sides)

Empty cereal box

Envelopes in assorted sizes

Armoire door illustration

TOOLS

All-purpose glue or spray adhesive

Pencil

Craft knife

Pen

Instructions

1. Spread the paper on your work surface. Dot or spray the front of your box liberally with glue. Center the box over the paper, and press the box down gently to adhere. Touch up glue around the corners of the box, if needed. Allow the adhesive to dry. *a*

2. Now wrap the box as you would a gift, securing the paper with glue on all sides and trimming the paper as needed. Allow the adhesive to dry. (The paper seam should be on the back of the box.) *b*

3. On the front of the box (the side with no paper seam), using a pencil, lightly draw a large capital I. Try to maintain at least a 1" (2.5cm) distance from the top and bottom edges of the box. Using the craft knife, gently cut this shape into the box. Carefully fold back and crease the flaps.

(These flaps create the "doors" of the Armoire.) *c*

4. Now comes the fun part: jazzing up your armoire! Using glue, adhere the Armoire Door Illustration (opposite) to the front flaps of the Armoire. Allow the adhesive to dry. *d*

5. Label the "drawers" (envelopes) of the Armoire. Match up contents with appropriately sized envelopes (say, large for dolls, medium for dresses, and small for accessories). Write the name of each envelope's contents on the front before tucking it in. *e*

You now have a lovely little place to store your dolls, as well as their clothing and accessories!

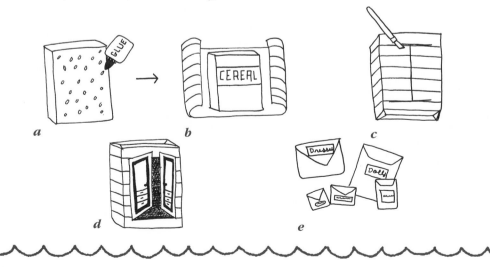

a b c

d e

ARMOIRE DOOR ILLUSTRATION

Photocopy illustration at appropriate percentage to best fit your box, if desired.

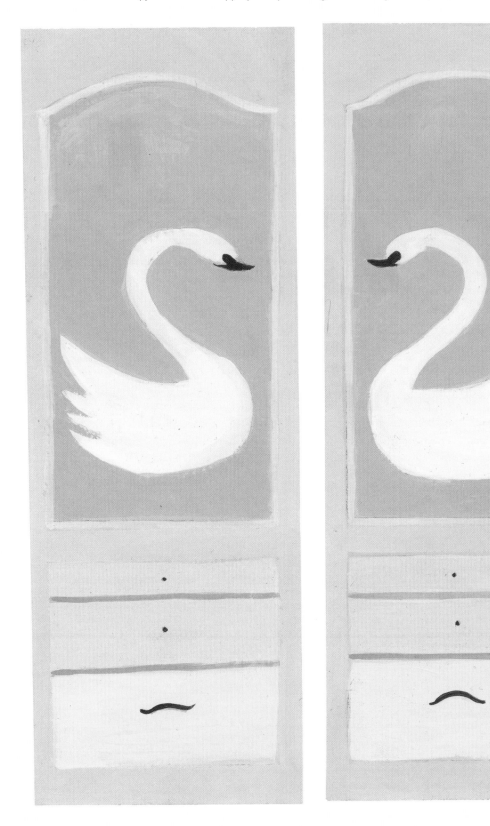

Play Set

This little project is a snap to create, and perfect for **really playing** with your dolls (especially for kids). Because paper dolls have a hard time standing upright on their own, we're going to use a secret weapon to create mini-stands: binder clips! These pinchy black office supplies are eminently useful for propping up paper dolls and their scenic backdrops. This is just a smidge more advanced than using your fingers as the paper doll stands, but it makes the dolls more like little action figures. Happily, since everything is very simple and lightweight, you can take the whole shebang wherever you'd like to go. (And while these are certainly snappy and convenient, if you're looking for a more permanent and sophisticated display stand, hop on over to page 142).

MATERIALS

One 11" x 17" (28cm x 43cm) sheet of poster board (or light cardboard)

One scene from The Scene Library (pages 66–77)

As many paper dolls as you like

Binder clips, ⅝" (16mm) or similar size (1 for each paper doll and 2 or 3 for the scene)

TOOLS

Spray-mount adhesive (or rubber cement)

Scissors (or craft knife)

Instructions

1. Lay the poster board flat on your work surface. Using spray-mount adhesive, mount each side of the scene to the poster board so that the pieces are joined in the center. Using scissors or a craft knife, trim excess board.

2. Attach 2 or 3 binder clips along the bottom edge of the scene, with shiny metal arms extended. Stand the scene upright.

3. Attach a binder clip to the feet of each doll in the same manner as for the freestanding scene.

ODDS & ENDS

✳ Taking your Play Set on the go? Toss everything (mounted scenes, dolls, etc.) in a large envelope, and attach the binder clips along the top and sides. This closes the envelope securely and ensures that everything (stands and things-to-be-stood) is in one place.

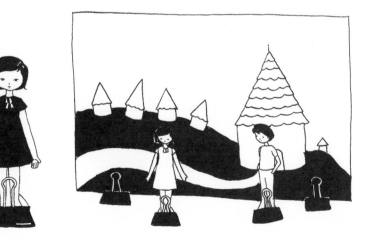

Upstanding Stand

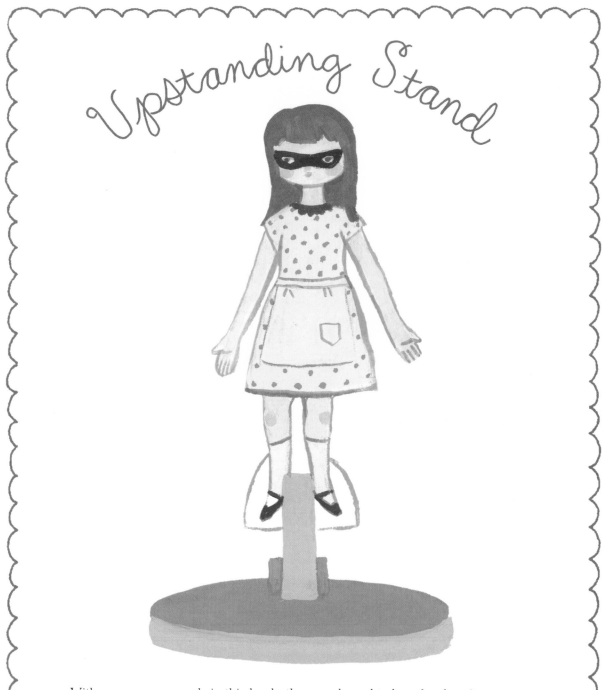

With so many paper pals in this book, there are bound to be a few favorites you might like to have out, just to keep you company or to display on your desk or bookshelf. Whether it's the tiny Paper You version of yourself or your sweeties, or one of my characters, turn your wee pal into a member of the upright paper doll brigade with this simple, sweet wooden stand.

MATERIALS

One small wooden circular plaque (about ½" [13mm] thick, and 5" [12.5cm] in diameter)

One ¾" (2cm) or 1" (2.5cm) wooden cube

Hint: The wood plaque and cube can be found at any large craft store.

One standard wooden clothespin

Craft paint in desired color

TOOLS

Medium-grit sandpaper (optional)

Paintbrush

Wood glue

Instructions

1. Lightly sand any rough edges on the wood pieces, if desired. Clean wood surfaces of any dust, and paint the plaque, cube, and clothespin in your chosen color. Allow them to dry completely. Apply a second coat of paint if desired, and let it dry.

2. Using wood glue, adhere the wooden cube to the base of the clothespin. Allow the adhesive to dry completely. *a*

3. Using wood glue, adhere the cube to the center of the circular plaque. Allow the adhesive to dry completely. Ta da! You now have a simple, refined little wooden stand for your favorite dolls.

a

ODDS & ENDS

✳ This stand would also work well holding postcards, photographs, and pretty much any other small, flat piece of ephemera you fancy.

Jointed Doll

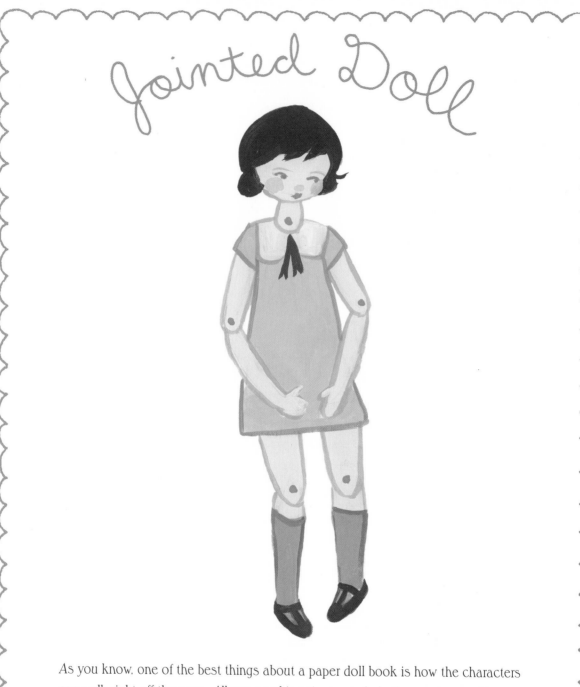

As you know, one of the best things about a paper doll book is how the characters can walk right off the page. All you need is scissors to help them get up and leap out of the book. But once they're free, how do you get them to move around? Why, by giving them joints, just like a real person (or a marionette)! Once they can move about, you can photograph that movement and create either a Flip Book or a stop-motion film (page 146).

Chosen paper doll, cut out (including the area around the feet)

Small brads, about 9–12 per doll

TOOLS

Pencil

Scissors

Small hole punch (in a diameter that will fit your brads)

Instructions

1. Using a pencil, draw a line where each joint (neck, shoulders, elbows, wrists, hips, knees, and ankles) should be on your doll.

2. Using the scissors, carefully cut the lines you just drew. Round any sharp corners. *a*

3. Using the hole punch, punch holes in each cut piece. (These are the points that will be jointed together.)

4. On your work surface, roughly arrange the doll's body parts where they should join together. Join each joint with a brad. Test your doll to make sure it moves properly— it should now resemble a miniature marionette. *b*

Repeat with any other paper dolls that you'd like to get moving!

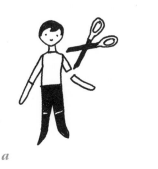

a

b

ODDS & ENDS

✴ A jointed doll folded up neatly inside a card and envelope and mailed or presented to a deserving recipient would make for a sweet and unexpected little toy or tiny gift! Something about the movement makes a simple paper doll seem all the more magical and substantial.

Flip Book

MY
PHOTOGRAPHIC
Flip
Book

OR, STOP-MOTION FILM

Back in Ye Olde *Art School*, one of my all-time favorite classes was a stop-motion film class. It was in this infinitely cool class that I learned that flip books and stop-motion movies are made using exactly the same principle. Neat, right? And jointed paper dolls make the perfect stars for either. With this project, your paper dolls will really come to life—and you can be as low- or high-tech as you want to be. Created with the help of a simple digital or film camera, this little production can take place on the unlikeliest of stages: your own refrigerator!

MATERIALS

Adhesive-magnet "paper" or strips

Jointed doll(s) (page 144)

Scene(s) from The Scene Library (pages 66–77)

Double-sided tape

2 large binder clips (for flip book only)

TOOLS

Scissors

Tripod

Digital camera (for flip book or stop-motion film) or 35mm film camera (for flip book only)

Photo printer

Magnetic surface (such as a refrigerator)

Film-editing software, such as Apple's iMovie (for stop-motion film only)

Instructions

1. Snip the magnets into small pieces (about ¼" [6mm] square). Adhere a mini-magnet to each individual section (head, torso, upper arm, lower arm, etc.) of the doll(s).

2. Adhere scenes to your magnetic surface with strong double-sided tape. (This creates a magnetic stage!)

3. Set up the tripod and camera in front of the "magnetic stage."

4. Devise a simple movement for your doll(s), like a curtsy. Plot out a point A (start) and a point B (finish).

5. Place your doll in the first position needed to begin the movement, and snap the first photo. (This is where it comes in handy that your doll is mounted to magnets, so the doll will keep perfectly still—until you move it again.)

6. Change the doll's position the tiniest bit—say, move the arm ¼" (6mm) toward point B—and snap a second photo. (The movements must be small, so when the photographs are strung together, they will seem somewhat fluid. This step is the heart and essence of stop-motion animation.)

7. Repeat step 6 as many times as necessary, until you've completed the larger movement (from point A to point B). It might take 36 frames, or it might take thousands (if you get terribly ambitious)! *a*

8. Finally, *if you'd like to create a flip book,* print your photos. Stack the prints in chronological order, with the first picture on top and the last one on the bottom, and bind them on the left with two large binder clips. *Voilà!* A flip book of your very own! *b*

If you'd like to make a stop-motion film, upload the digital files to your computer. Armed with specialty editing software such as iMovie, arrange and edit your frames, add a sound track, and create a playable movie!

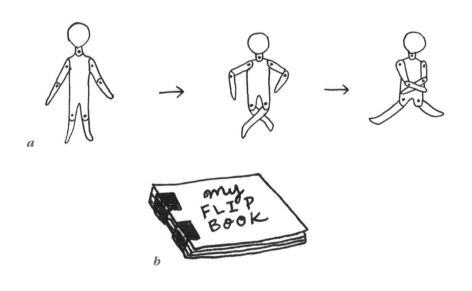

a

b

ODDS & ENDS

✷ For a little added pizzazz, make some fancy "title cards" for your flip book or movie.

✷ One of these flip books would make what is likely to be the best birthday card ever. I can't imagine how dazzled the recipient would be.

Stationery

Now that you've made paper doll versions of you and yours (page 94), think about some of the advantages they have. The dolls look like you but are small and flat enough to fit into an envelope and then travel across the country for the piddling cost of a stamp or two. Now, let's say you want to pay your mom a visit on Mother's Day, but you can't swing the airfare. Just send your cute little two-dimensional doppelgänger!

From save-the-date postcards to thank-you notes and wedding party invitations, your customized dolls can add a personal touch wherever they pop up. All you need is a scanner or a color photocopier, and custom paper goods are just a hop, skip, and click away.

MATERIALS

Paper You doll(s)

Several sheets of paper: 8½"
x 11" (21.5cm x 28cm) copy
paper or card stock, or precut
and presized specialty cards

TOOLS

Scanner and computer

Graphics software (such as
Photoshop)

Printer

Instructions

1. Using a scanner, scan the doll(s) at a resolution of least 300 dpi.

 Hint: See page 94 for instructions on making custom dolls.

2. Using graphics software, manipulate the scans—play around with moving, resizing, duplicating, and otherwise customizing your scanned doll image. Try using colored backgrounds and fun fonts with your doll images to create perfectly personalized stationery.

3. Using a printer, print your customized scanned image onto your paper of choice. Write your note, and your stationery is ready to mail!

Using Color Photocopies

If you don't have a scanner and graphics software available, that's perfectly okay. Instead, go to a copy shop and make (or have them make) color photocopies of your custom dolls. You can even resize the dolls to make stationery and cards of different sizes (for example, try photocopying the dolls at 50 percent for a small note card).

Once you've got your copies (don't risk using the original), play around with the placement of the doll(s) on card stock or letter paper, and add handwritten or typed text. When you're happy with the arrangement, adhere these elements with spray adhesive. Use the mixed-media stationery as is, or make additional color copies for giving.

Choosing Paper for Stationery

1 large folded card	5½" x 8½" (14cm x 21.5cm) folded	Fits A9 envelopes
2 large postcards	5½" x 8½" (14cm x 21.5cm)	Fits A9 envelopes
2 small folded cards	4¼" x 5½" (11cm x 14cm) folded	Fits A2 envelopes
4 small postcards	4¼" x 5½" (11cm x 14cm)	Fits A2 envelopes
8 extra-small place-setting cards	2¾" x 4¼" (7cm x 11cm) folded	

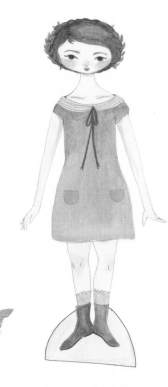

I like to mail a little something to friends and family on holidays. This little nature girl would be just the ticket for National Arbor Day.

ODDS & ENDS

✳ Use copies of your dolls, dresses, and other accessories on card stock to create cute, personalized gift tags and labels. Write **To** and **From** on the back, punch a hole through the top, and string them onto a package (or simply tape them on).

✳ Use a scaled-down version of a Paper You doll (reduced to 50 percent or so) as a simple loose enclosure inside other cards or invitations. The recipients will be delighted when a tiny surprise passenger slips out of their correspondence!

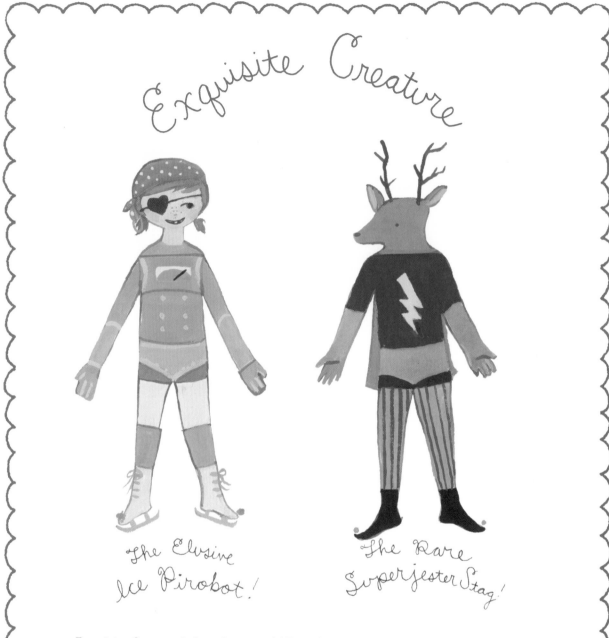

Exquisite Creature

The Elusive
Ice Pirobot!

The Rare
Superjester Stag!

Exquisite Creature is based on an old French parlor game called *Cadavre Exquis* ("Exquisite Corpse"). This game was played by several people, each of whom would write a few words on a sheet of paper, fold the paper to conceal their contribution, and then pass it on to the next player. The legend goes that the game got its name from the first game ever played: *Le cadavre / exquis / boira / le vin / nouveau.* ("The exquisite corpse will drink the new wine.") Kind of like *Mad Libs* for turn-of-the-century café society. Before long, the game was adapted to drawing, which is what we'll be doing here!

MATERIALS

Photocopies of the Exquisite Creature template, page 154

3 people (total) to play along!

Various art supplies: pens, pencils, and markers

Instructions

1. Fold a photocopied template into 3 accordion folds along the dotted lines. *a*

2. The first player illustrates the top ⅓ of the template (head); folds her illustration behind the paper, so her contribution will stay hidden; and passes the template to the second player. *b*

3. The second player illustrates the next ⅓ of the template (torso and arms), folds his illustration behind the paper, and passes the template to the third player.

4. The third player illustrates the bottom ⅓ of the template (legs and feet).

 Hint: Remind the players to draw their contributions secretly and fold the paper before passing it on, making sure to hide their illustrations. The point of the game is to be surprised when all three parts are revealed!

5. Time for the grand reveal! Unfold the template so that everyone can see the curious creature the 3 talented illustrators have created. *c*

a *b* *c*

Exquisite Creature (continued)

Using this template—which can be copied as many times as needed—you'll have a three-person collaborative art project: a paper doll with three parts that, ideally, will be as quirky as the three contributors. Think mummy head, belly dancer midsection, and robot legs . . . that's an example of what your crazed imagination might create!

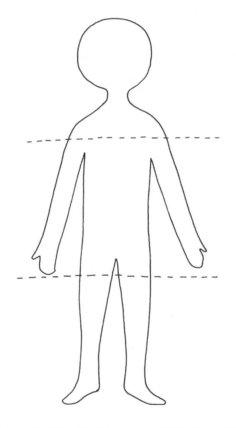

EXQUISITE CREATURE TEMPLATE

ODDS & ENDS

✦ Did you create a modest monster? Unless someone made profound changes to the outline of the template, the mismatched doll creations produced by this game should have no trouble wearing the children's clothes provided in the custom section (pages 122–127). Just trim to fit.

Mobile

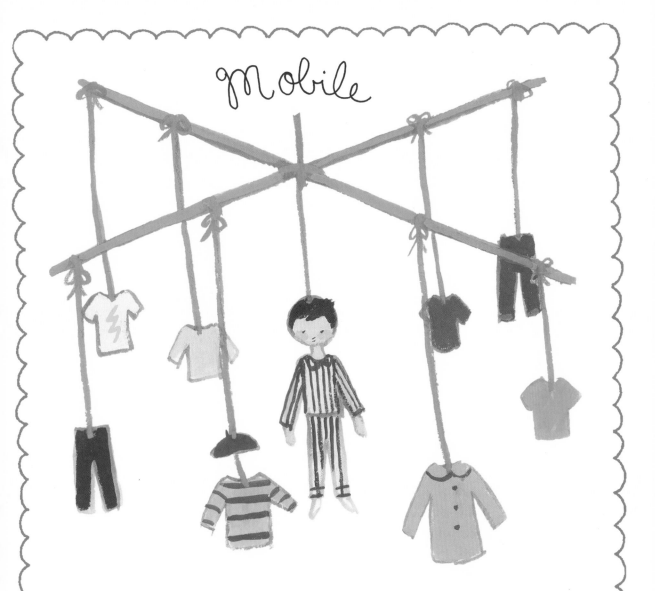

You already know you can display paper dolls with a picture frame, but how about with that old-timey charmer, the mobile? Using the most common materials (such as chopsticks and string), you can make your own floating panorama. You can choose any element (dolls, clothes, or even etceteras) in the book for this project, and depending on your choices, you will create a completely different look or feel.

How about twelve tiny dresses spinning from the ceiling of a little girl's room? Or a carousel of characters, using your favorite paper people from any part of the book?

Mobile (continued)

MATERIALS

8–16 elements from this book (dolls, clothes, or etceteras)

4–8 pieces of string 8" (20.5cm) long (one each for half the total number of chosen elements)

4–8 pieces of string 12" (30.5cm) long (one each for half the total number of chosen elements)

String to hang mobile

2 chopsticks (or 2 chopstick-sized wooden dowels)

Tack or small hook for mounting to ceiling

Hint: If desired, vary the lengths of string used to suspend your elements to add visual interest.

TOOLS

Small hole punch (the smallest size that will accommodate your string)

Scissors

Instructions

1. Using the hole punch, create a hole about ¼" (6mm) in from the top of each element. (This hole is where you will hang the element. Make sure that the hole is centered so the element will hang straight.) *a*

2. Gently tie each element to the end of a length of string.

3. Cross the chopsticks to make an X shape. Wrap the center of the X with string, alternating wraps on each side until the shape is held firmly in place. Knot string to secure, but do not cut the end of the string. (This X is the mobile frame from which the elements will hang.) *b*

4. Tie the elements onto the mobile frame in a way that is pleasing. Symmetry can be good, but so can an asymmetrical cascade! Play around with it until your elements float and mingle together in a way that you like. *c*

5. Measure out how far you'd like your mobile to hang from the ceiling. Cut the tail end of the string to that length. Tie a loop in the end of the string and hang it from a small hook or tack in the ceiling.

Now step back and enjoy your darling dangling display!

a *b* *c*

ODDS & ENDS

✳ Using the same technique (punching small holes in the tops of dolls and clothing from the book, and threading with loops of strings), you could create some seriously cute Christmas ornaments. Deck the halls with tiny sweaters!

ABOUT THE AUTHOR

Likes

Nutmeg,
Cursive Letters,
Old Dresses

Dislikes

Mealy Apples,
Scratchy Sweaters,
Phonies

Emily Winfield Martin is a painter, stitcher, and scribbler (and a first-class hot chocolate connoisseur). When she was small, her best friends were her books, her rabbits, and her dad. When she grew up, she studied painting, photography, and English literature at the University of Georgia in the sunny South where she was born. She now lives among the giant firs of Portland, Oregon with her best fella, Josiah, and her darling, rotten cat, Miette. She works in a tiny, cozy studio with towering stacks of old fabric and dusty books, and a toy piano.

Emily has been creating and selling her artwork, dolls (paper and otherwise), and curiosities under the moniker "The Black Apple" since 2005. She has been featured on *The Martha Stewart Show*, in the *New York Times Magazine*, and was voted *Venus Zine* magazine's Best Indie Business in 2007. Her blog, Inside a Black Apple (www.the blackapple.typepad.com), contains a mishmash of new artwork, Black Apple official business, inspiration, and odds & ends.

Emily draws inspiration from autobiography, early to mid-twentieth century children's books and toys, comics, carnivals, natural history museums, fashions of the 1930s and 1960s, and her favorite bands. Currently, she is working on several children's books, and keeps busy as a bee with both personal and collaborative art and illustration projects.

INDEX